Beginning
COMPOSITION

Tips and techniques for creating well-composed
works of art in acrylic, watercolor, and oil

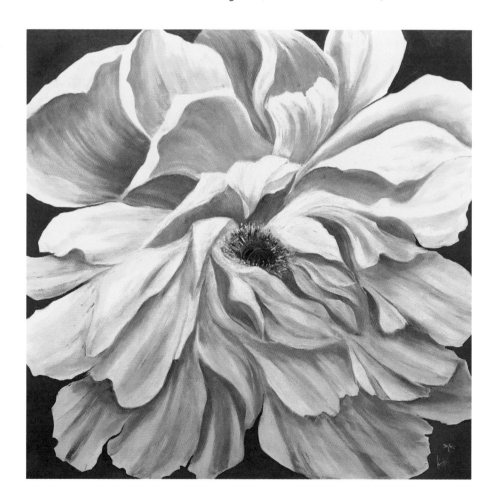

Brimming with creative inspiration, how-to projects, and useful information to enrich your everyday life, Quarto Knows is a favorite destination for those pursuing their interests and passions. Visit our site and dig deeper with our books into your area of interest: Quarto Creates, Quarto Cooks, Quarto Homes, Quarto Lives, Quarto Drives, Quarto Explores, Quarto Gifts, or Quarto Kids.

Inspiring | Educating | Creating | Entertaining

First published in 2019 by Walter Foster Publishing, an imprint of The Quarto Group. 26391 Crown Valley Parkway, Suite 220, Mission Viejo, CA 92691, USA.
T (949) 380-7510 **F** (949) 380-7575 **www.QuartoKnows.com**

Walter Foster Publishing titles are also available at discount for retail, wholesale, promotional, and bulk purchase. For details, contact the Special Sales Manager by email at specialsales@quarto.com or by mail at The Quarto Group, Attn: Special Sales Manager, 100 Cummings Center, Suite 265D, Beverly, MA 01915, USA.

ISBN: 978-1-63322-793-4

Digital edition published in 2019
eISBN: 978-1-63322-794-1

Printed in China
10 9 8 7 6 5 4 3 2 1

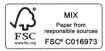

MIX
Paper from responsible sources
FSC® C016973
FSC
www.fsc.org

Table of Contents

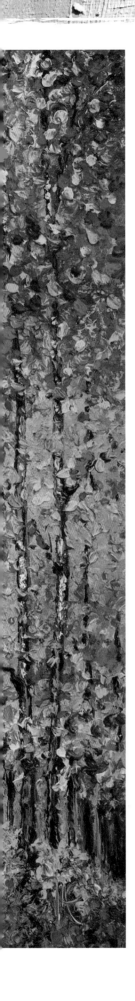

Introduction

**"NO ONE IS AN ARTIST UNLESS HE CARRIES HIS PICTURE IN HIS HEAD BEFORE PAINTING IT AND IS SURE OF HIS METHOD AND COMPOSITION."
—CLAUDE MONET, FRENCH PAINTER**

Have you ever looked at a painting and thought that something—the color, subject, or proportions—doesn't seem right? It's not always easy to pinpoint exactly what is "off" in an artwork, but something will tell you that it isn't quite right. Those little subtleties are usually caused by a bad composition.

Composition refers to the placement of elements within an artwork. Artists follow certain guidelines to evoke emotion and portray a story in a piece of art. Like following the steps of a great recipe, successful composition requires understanding how much of each element to add and when to add it. If you add too much salt to your grandmother's famous soup recipe, those eating it will notice its brininess. Similarly, if you add too many elements to an artwork or the placement of the elements looks unbalanced, your viewers will most certainly notice.

Composition is a large and in-depth subject, and throughout this book, I will introduce you to many of the basics that all beginning artists should know, as well as offer a refresher for intermediate and advanced artists. This book also includes tips on how to approach planning a composition and step-by-step painting projects using reference photos. I've incorporated the works of a few other artists as well to show how the same elements can be used with different styles and subjects.

I hope this book will help give the you the foundation needed to create artwork that portrays the story you intended. Happy painting!

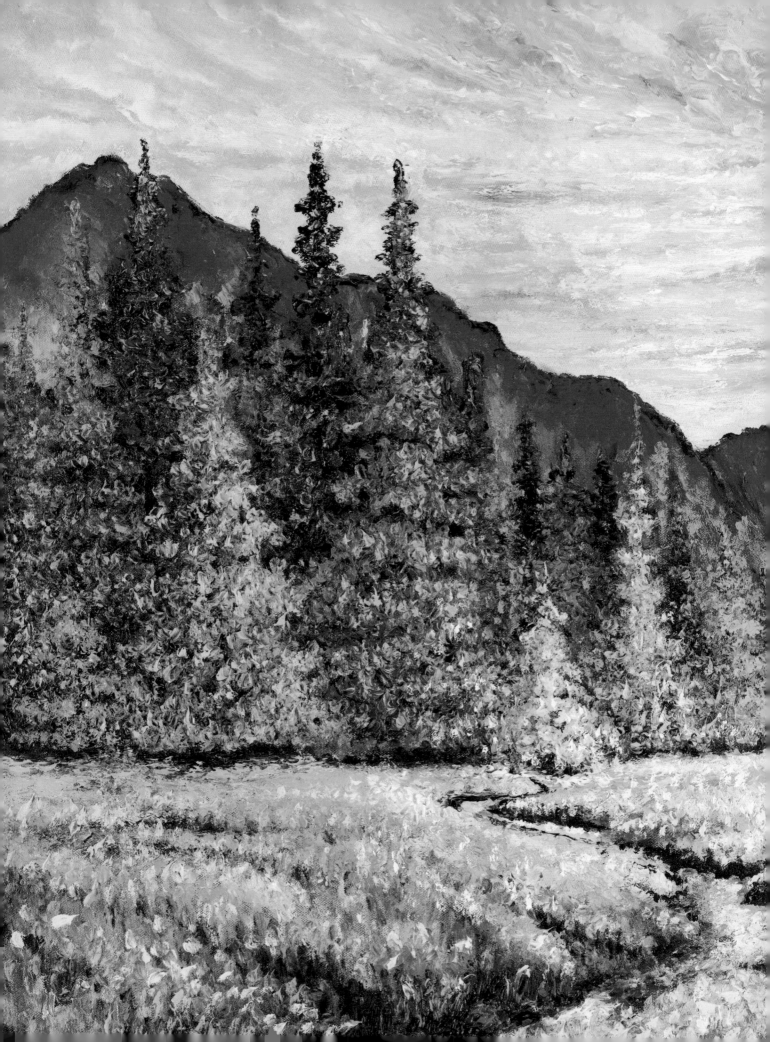

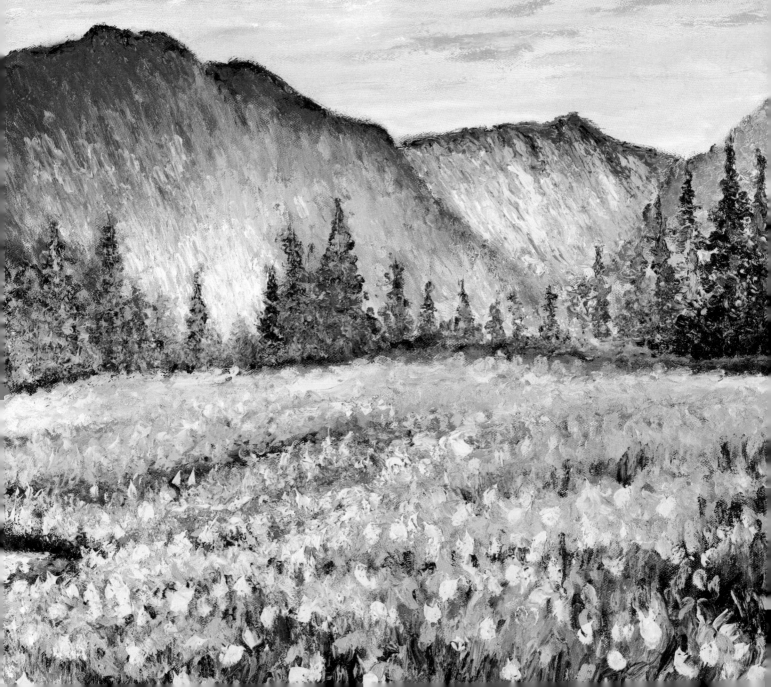

GETTING

Started

Setting Up Your Workspace

Before applying paint to a canvas or putting pen to paper, it's crucial to plan a starting point. What's the story you wish to tell? The placement of each element in the painting or the subject you are drawing is key to creating a masterful work of art.

Having the right space to allow your creativity to flow is also important. Here are a few things to consider when choosing where to paint.

THE RIGHT PLACE

You'll realize the value of having a well-lit space once you start to draw or paint. Shadows and a glare from your light source can be distracting and may cause you to overcompensate the values or images in your artwork.

Choose a painting location that features a good source of natural light. Painting outside (*en plein air*) is wonderful. If artificial light is your only option, ensure that there is enough lighting to prevent shadows or a glare. Track lighting works well, or place several light sources in the room so that one doesn't dominate. Kitchens often come equipped with great lighting and offer the ideal space to perfect your work.

THE RIGHT MOOD

The music you listen to can affect what you paint. Several artists have told me that they like to choose a playlist or a certain kind of music that mirrors what they hope to convey through their artwork. Some artists listen to audiobooks, while others seek out quiet spaces in which to paint. Spend time considering what will help clear your thoughts so that you can fully engage with the subject of your artwork.

THE RIGHT FRAME OF MIND

I have ruined paintings by not being in the right frame of mind. I've tried to paint while worrying about the long list of things I needed to accomplish later that day. Instead of thinking freely about what I was creating, I was distracted by what needed to get done. Not only did I not enjoy the painting experience, but I also made several errors and ultimately had to start the pieces over again.

Before starting a painting, I suggest clearing your mind by going for a walk or meditating. If that isn't needed and the process of painting can clear your mind of its everyday clutter, do a few quick sketches to get yourself in the right frame of mind before beginning your artwork.

Tips, Tools & Materials

Various tools can be used to help plan the perfect composition, and each serves a specific purpose within art. Here are a few of my favorite tools.

GRID This quick reference guide can help you visualize the rule of thirds, or the visual guideline that divides an image using two horizontal and two vertical lines, as shown in this example. Placing the image's subject where the lines meet creates a focal point that draws the viewer's attention.

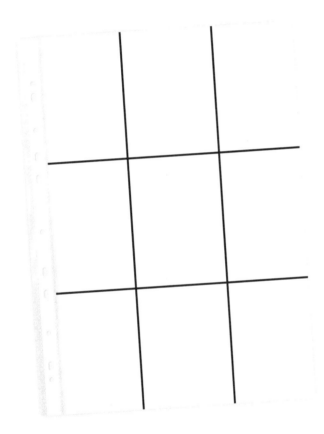

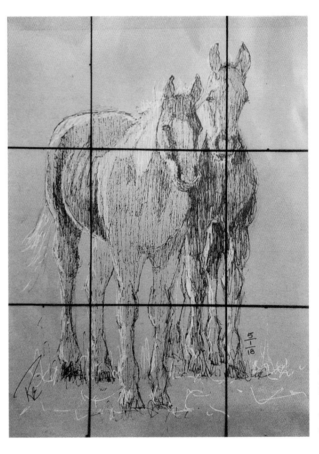

Artist: Ré St. Peter

DIY GRID When I teach painting classes, I often instruct my students to draw a grid on their canvases. One of my students came up with the clever idea to draw a grid on a plastic sleeve and place her reference photo inside. I now share this tip with all my students to help them visualize the rule of thirds.

Premade grids to help you crop your images can be purchased online and in any photography or art store. These tools are great for painting en plein air or using a reference photo.

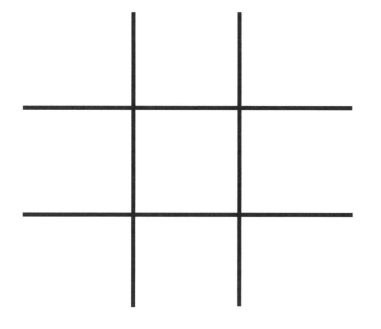

I created the DIY grid on page 10 from a plastic sleeve that can be purchased online or in any office-supply store. To make your own, position the plastic sleeve horizontally, and measure a third of the way from the top and the bottom. Use a ruler and a permanent marker to draw lines that separate the sleeve into thirds. Then turn the sleeve vertically and add two more lines to the grid.

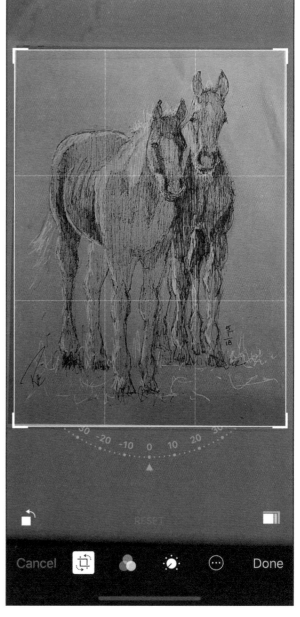

NEWER SMARTPHONES COME EQUIPPED WITH AN EDITING TOOL THAT INCLUDES THE OPTION TO PLACE A GRID OVER A PHOTO AND THEN CROP IT.

Artist: Shelly Wilde

PROJECTOR

Before beginning a painting, artists often use a projector to show an image on a wall, canvas, or paper. This is another clever way to use technology to ensure that you've planned a strong composition before you start painting.

VALUE FINDER An important element of creating a strong composition is accurately representing the light, medium, and dark values in your artwork. A value finder features a reference scale of gray values, ranging from white to black, and can be used to determine the values in your image.

I use one that's made from red cellophane, which brings a colorful painting into grayscale and allows me to check the proper range of values in my reference photo.

RULER This tool isn't just handy for drawing a straight line. I use a straightedge to check the angles when I'm painting a landscape, human figures, and many other subjects.

In this example, I used a straightedge to draw lines on my reference photo to help define the angles and distance between the elements, ensuring that I had the perspective right before I started painting.

tip

IF THE PERSPECTIVE IN A PAINTING LOOKS "OFF," I REFER TO THE ANGLES I'VE DRAWN ON MY REFERENCE PHOTO TO SEE WHERE I MAY HAVE MADE A MISTAKE.

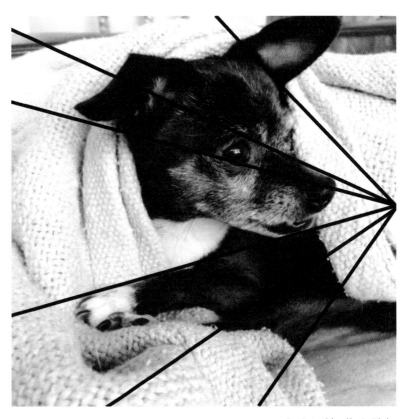

Artist: Shelly Wilde

SKETCHBOOK

The sketches you make before touching paint to canvas will form the foundation of your artwork. Throughout this book, I will discuss the importance of planning before you start painting. A sketchbook in which to capture your ideas and plan out different perspectives is the most important tool you can have, along with a pencil or pen.

Basic Techniques

"I NEVER RETOUCH A SKETCH: I TAKE A CANVAS THE SAME SIZE, AS I MAY CHANGE THE COMPOSITION SOMEWHAT. BUT I ALWAYS STRIVE TO GIVE THE SAME FEELING, WHILE CARRYING IT ON FURTHER."
—HENRI MATISSE, FRENCH ARTIST

To build confidence in your art and create a successful composition, you must **plan**, **practice**, **and have a purpose.**

Planning guides you to your destination (in this case, a successful composition) and gives purpose to each step in the painting or drawing process. It will also help show you the areas you may need to correct if something in your artwork doesn't turn out as planned.

Practice gives you the skills necessary to recreate what you've envisioned. There is something to be said for the concept of "practice makes perfect," as even the most experienced artists continue to work on perfecting their skills over time.

When you place objects in your artwork, you do so with **purpose** to tell a story and/or keep your viewers interested in what you've created.

After the idea for an artwork comes to mind, the first step to planning and practicing is sketching.

THUMBNAILS

A trick to testing a good composition is looking at the image in thumbnail size. Shrinking the image allows you to see the image and the visual and compositional elements within it, so you can check for their appropriate placement within your artwork. Smartphone apps allow you to view an image in thumbnail size.

SKETCHING

As I mentioned previously, planning is one of the most important but overlooked elements of starting a painting. A sketch is the best way to determine if you have the right composition. You can sketch your ideas and play with different types of perspective, as well as plan out colors.

On this page and the next, I've included a couple of sketches from the watercolor artist Ré St. Peter. By sketching her subjects (two horses) in advance, she was able to adjust and test their positions. This gave her the opportunity to make corrections and visualize the final result before devoting hours to her work, only to discover that something in the layout needed to be changed.

Placing a grid over the sketch helped the artist determine where to place the focal points of the image (see pages 10-11).

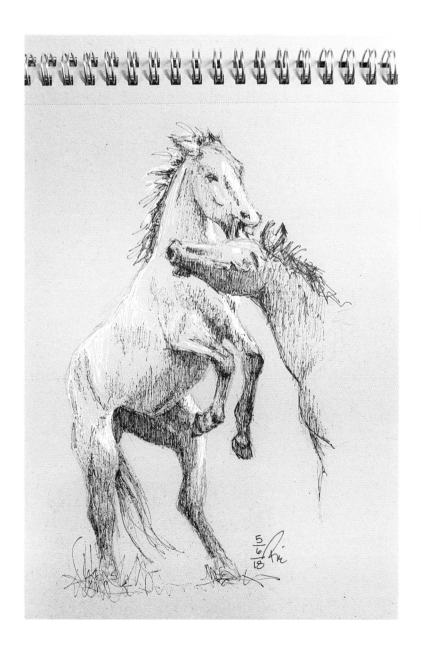

tip

KEEP A SKETCHBOOK FOR CAPTURING QUICK SKETCHES AND IDEAS FOR POTENTIAL PAINTINGS.

Artist: Ré St. Peter

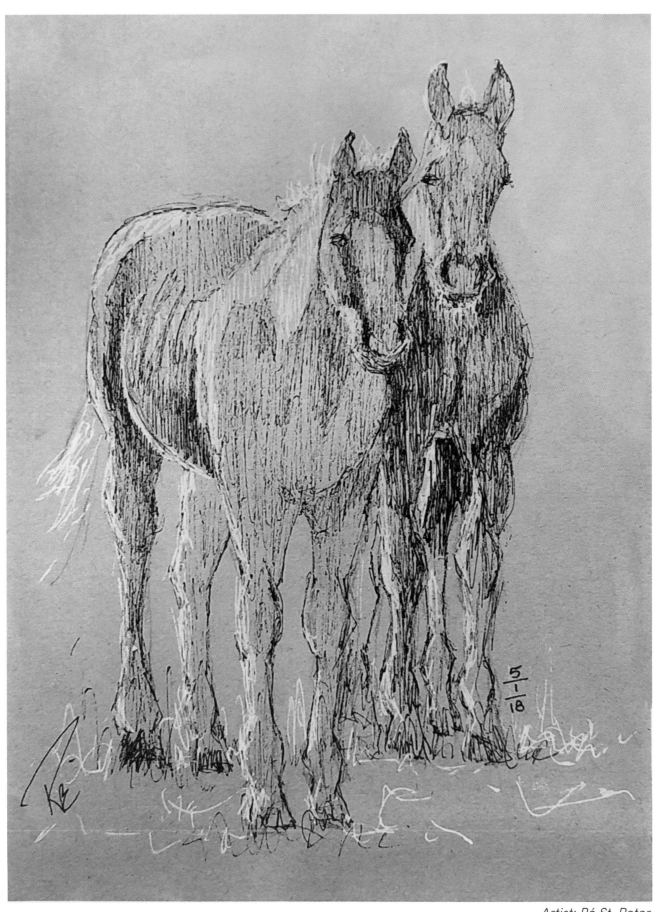

Artist: Ré St. Peter

Daily Challenge

Set yourself the goal of creating a daily sketch or study. This drill can be built into any daily routine, such as by drawing your morning cup of coffee. Capture it in different types of lighting or from various angles, or pair it with objects, like a spoon or the bottle of coffee creamer. As you increase your understanding of composition, you can become more purposeful with the design and your placement of elements. You can also troubleshoot what you didn't like about a specific sketch, and then fix it the next day.

Here, watercolor artist Amanda Schuster used a sketch to plan colors that complement the subjects in her final piece.

Artist: Amanda Schuster

CREATING A SKETCH

Your sketches don't have to be detailed; you can use them just as quick references for capturing the best composition in your final artwork. A good way to practice is by drawing the subjects you see in front of you, such as your cup, desk, window, and so on. Start by getting the basic shapes down and playing around with where you place the objects on the paper, whether it's in the middle or off-center, and feature the objects from different angles as well.

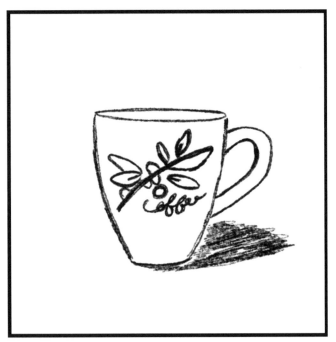

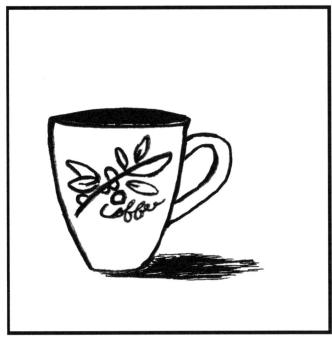

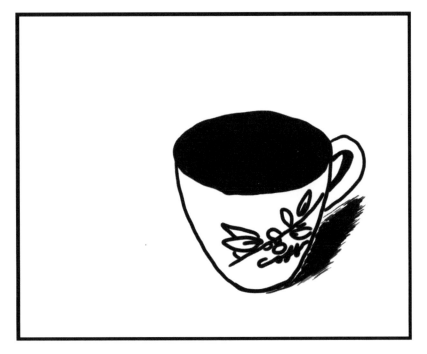

Here I've done three quick sketches of a coffee cup. Which one looks most interesting? The third one draws more interest, as it's placed in the bottom third of the paper and shown at a different angle, which invites curiosity and adds character.

Practicing with quick sketches will jump-start your creativity and help you become more mindful about where you place the subjects within your artwork. As you begin sketching, you may notice that your subjects look more interesting when they feature an odd number, as is the case with these trees. Which set of trees draws more interest and attention? Is it the one that features three or four trees?

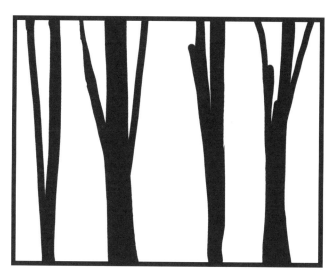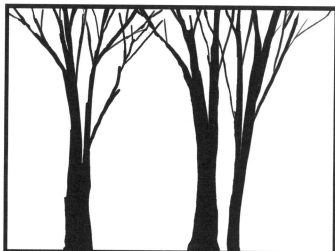

Now look at the images of dots. Which one is more attention-grabbing: the one with the dots placed in a uniform pattern, or the one where they're in random order?

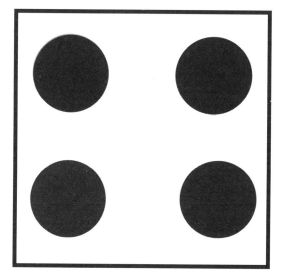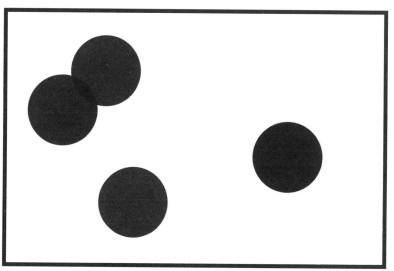

This book will explain why the randomly placed dots look more interesting and give basic instructions for becoming more purposeful as you place your subjects and use negative space to create a dynamic work of art.

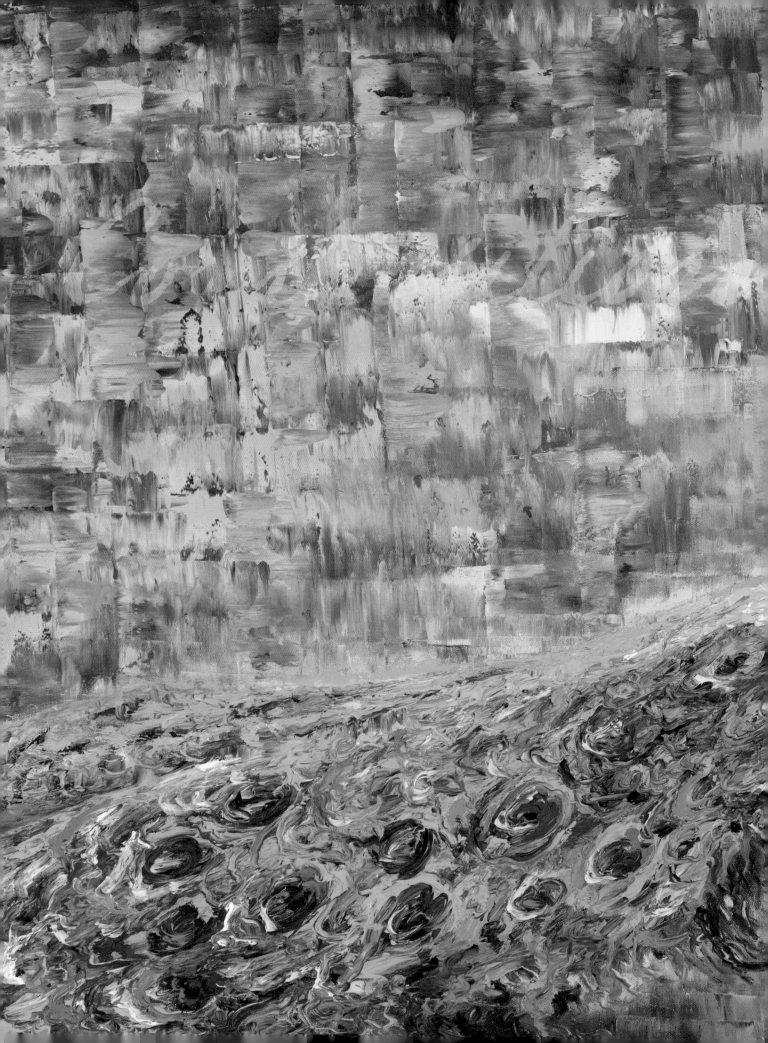

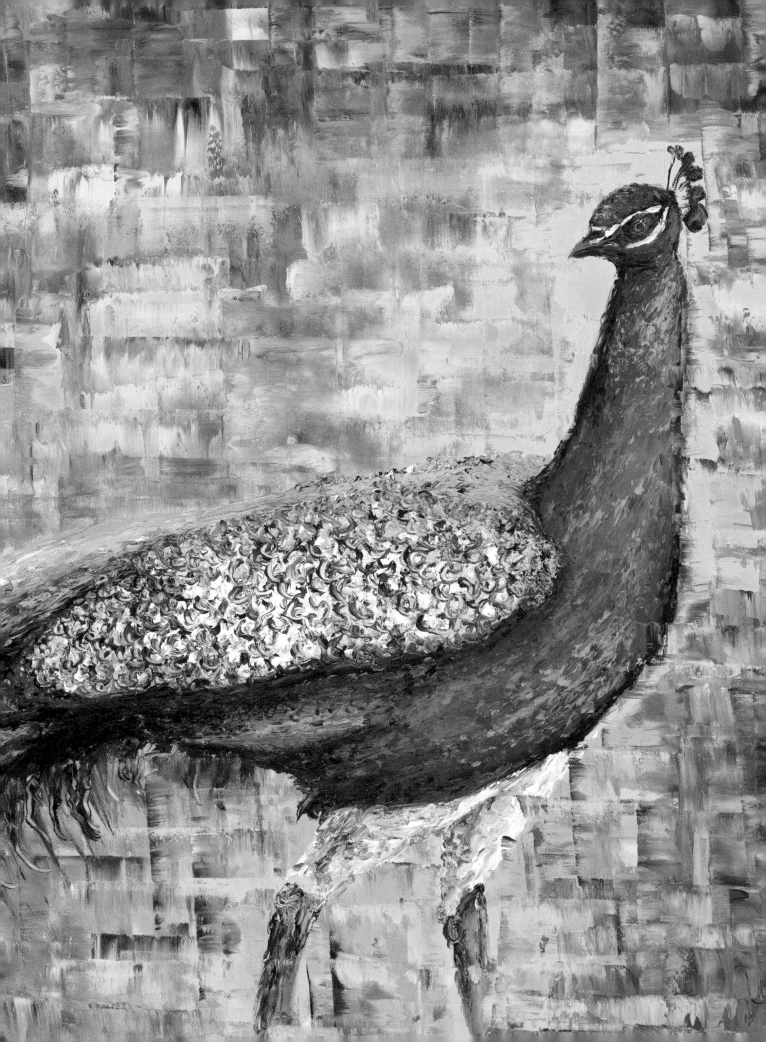

What is Composition?

The verb "compose" refers to the act of putting things together, while "composition" (a noun) refers to how things are arranged, or the planned placement of elements within an image. How an artist decides to place these elements determines the viewer's experience. A great composition is achieved when the planned placement of elements controls eye movement and leads the viewer through the painting. Composition is one of the most overlooked elements of planning a painting, but it remains essential to putting together a successful work of art.

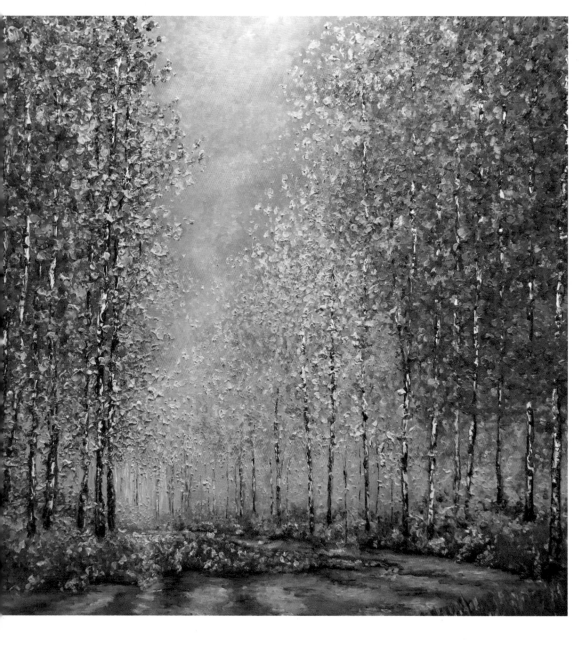

Look at the examples on pages 23-25, which the artist, Amanda Schuster, used to plan a landscape featuring a moonlit forest. The thumbnails provide demonstrations of a good, a better, and the best composition.

GOOD

Taking into consideration the rule of thirds (page 10), the first composition is good. The artist layered the forest horizontally, with the main subject (the trees) creating a backdrop for the lake, which takes up two-thirds of the sketch. The off-center moon invites curiosity and interest.

The purposeful placement of the elements tells the viewer that the trees and lake are the main subjects of the image, as they take up the majority of the space, while the moon has a supporting role. Placing the moon in the center of the image would distract the viewer from the main subject and prevent the eye from exploring the other elements in the drawing.

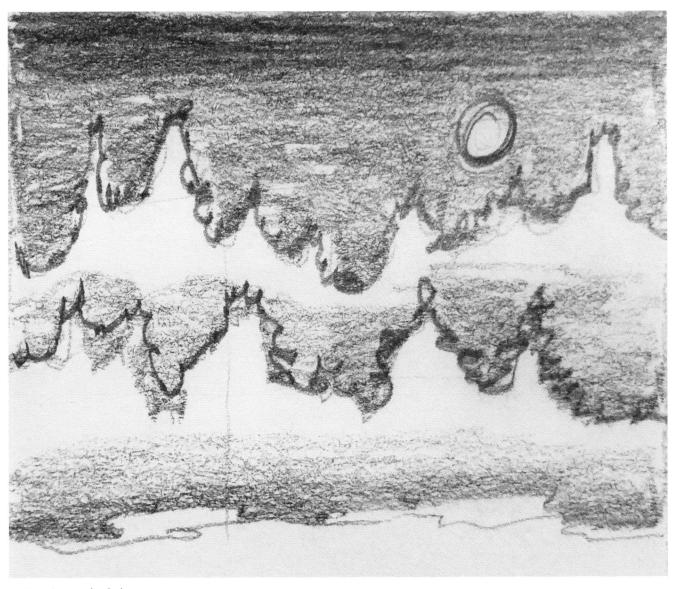

Artist: Amanda Schuster

BETTER

In the first thumbnail (page 23), the lake can be overlooked. Here, to improve the composition and draw attention to the lake, the artist moved the lake to the left side of the image. Still following the rule of thirds, the moon was moved too, creating a glow over the water.

This composition is better, as it inspires the viewer to study the elements in the drawing. The lake is more visible, and the concept of a moonlit forest is more noticeable.

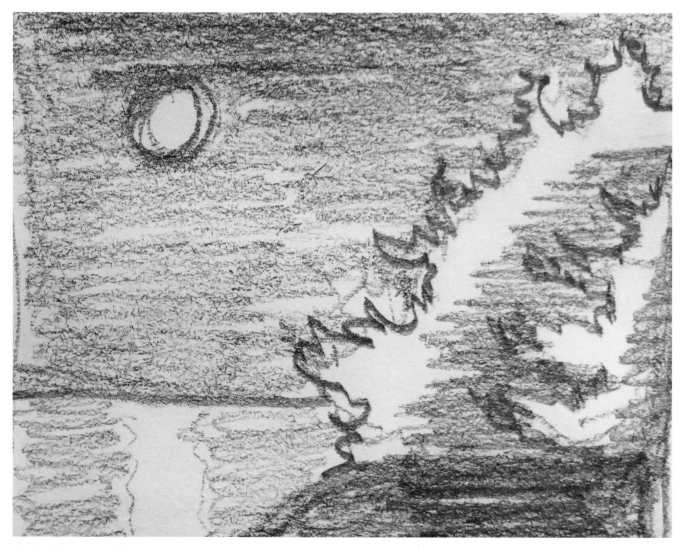

Artist: Amanda Schuster

BEST

Here, the artist has made the forest the star of the image, while the other elements take on supporting roles. Using the rule of thirds as a guide, the artist added more trees and gave them the most space within the image. The moon remains off-center and the lake is smaller.

This complementary composition places the elements in the best way to tell the story as the artist has intended. If the artist had moved the moon to the center of the image, placing emphasis on the moonlit glow, how would that change the viewer's experience?

The placement of elements within an image is important, so after drawing a sketch, ask yourself if your drawing tells the story you wish to tell. Which elements form the focal points? Do they support or distract from the subject of the image?

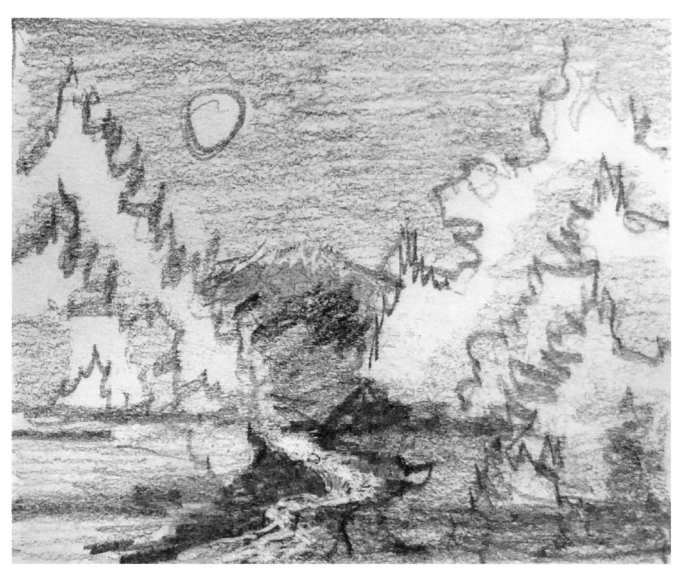

Artist: Amanda Schuster

IMPROVING AN ALREADY-GOOD COMPOSITION

Let's take this concept a little deeper. Look at the sketches by Lois Haskell below and to the right. The first image uses the rule of thirds as a guideline, placing the horizon line in the top third of the image. The benches are placed in the left third and the man is in the right third. This makes for a successful composition, as the trees, benches, and man form a circle that the eye follows. Placing the dog so close to the edge of the drawing can be risky, as it may lead the eye away from the rest of the elements.

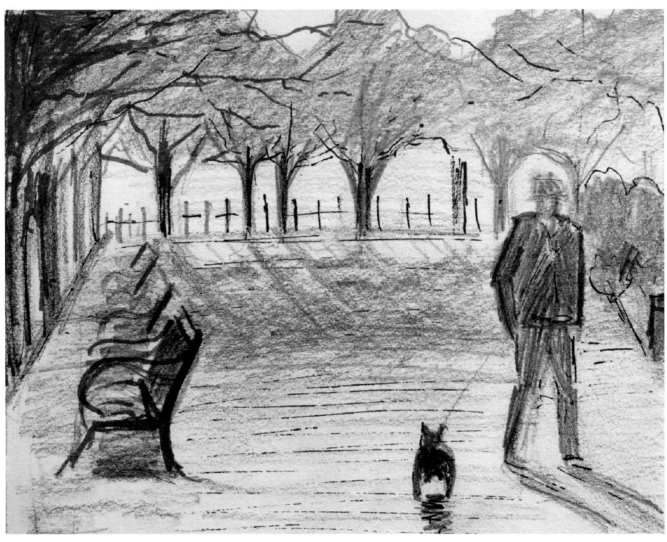

Artist: Lois Haskell

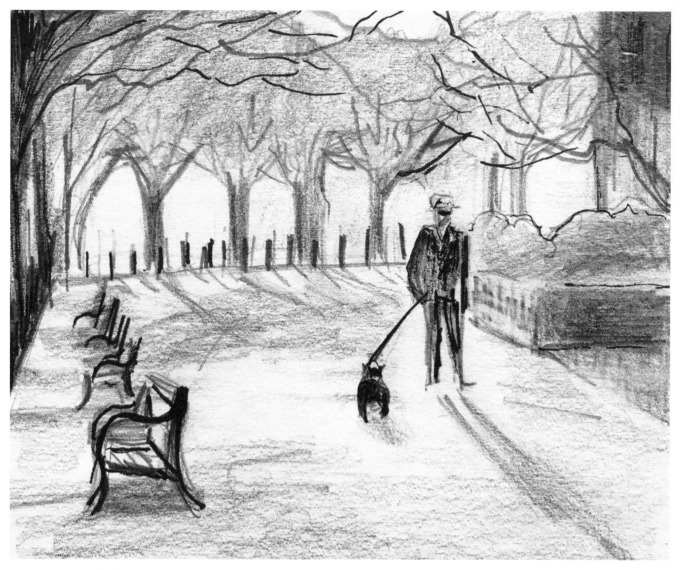

Artist: Lois Haskell

This image features a better composition than the one on page 26, as the man and his dog are placed farther back in the image. The subjects are less balanced, resulting in a more engaged viewer, whose eye is drawn to the man and his dog, while the angle of the leash leads the eye to the benches. The benches follow a line that digresses into the background, guiding the eye to the trees and horizon, which then leads the eye back to the man and his dog.

THIS PLACEMENT OF THE ELEMENTS AND SLIGHT ADJUSTMENT TO PERSPECTIVE HELP CREATE A STRONGER COMPOSITION BY TAKING THE VIEWER ON A JOURNEY THROUGH THE IMAGE.

Contrast & Value

Contrast refers to opposing values, such as black and white, rough and smooth, or large and small. It is often used to create a focal point. Value means a scale of light to dark. In an image, middle gray is the value point between the darkest and lightest tones. To create harmony in an image and place emphasis on a focal point, it's important to feature a range of light, medium, and dark values.

VALUE SCALE

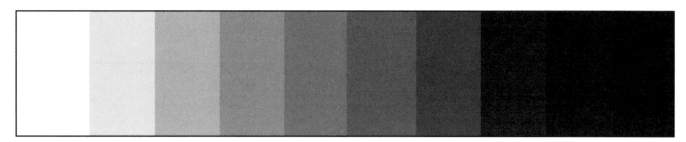

Light Medium Dark

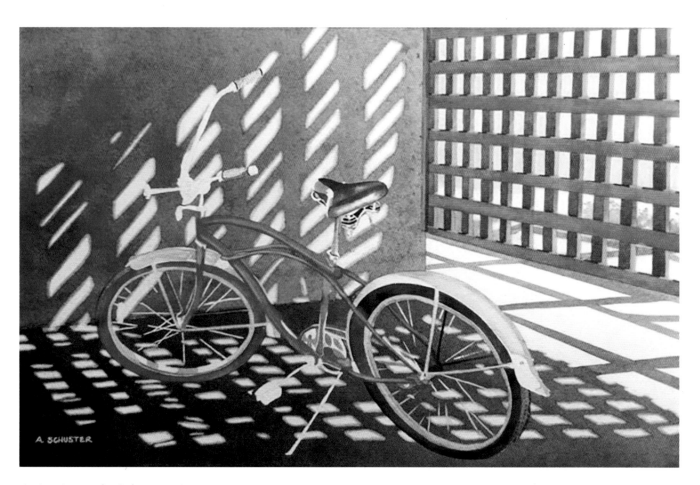

Artist: Amanda Schuster

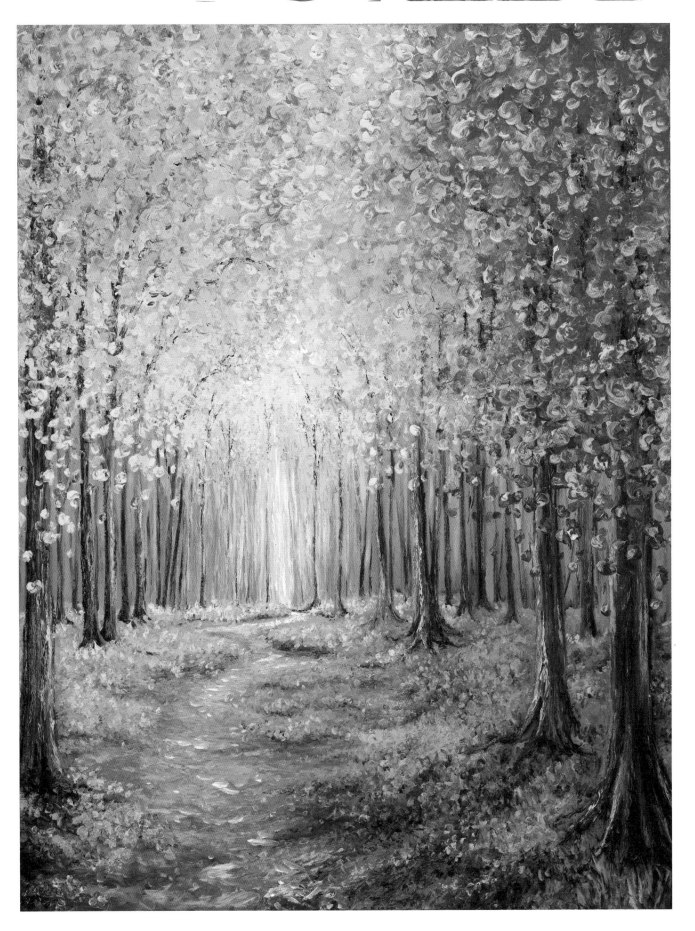

In this still life by artist Lois Haskell, the thumbnail sketch shows a value scale from light to dark. The background and tablecloth create the strongest contrast, placing the lightest part of the painting next to the darkest. This dramatic contrast is intentional, as it draws the eye toward this distinctive black-and-white point. From there, the eye should move through the elements arranged on the table in a variety of hues. Once you've created a sketch using light, medium, and dark values, you can consider which colors to add to the final painting, selecting ones that will represent the same values.

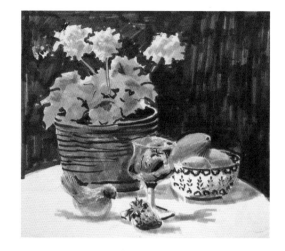

Artist: Lois Haskell

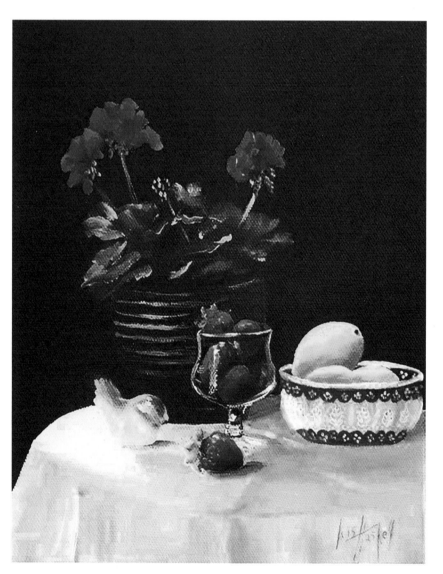

In the painting, the artist chose to keep the background in the darkest value to create contrast against the white tablecloth. The basket and green foliage feature medium and dark values to allow the colors in the flowers and objects on the table to "pop." The shades of red are painted in a triangular shape so that the viewer's eye will flow from top to bottom. The yellow bird and lemons help balance and draw attention to the subtle yellow highlights in the basket and foliage.

Artist: Lois Haskell

30

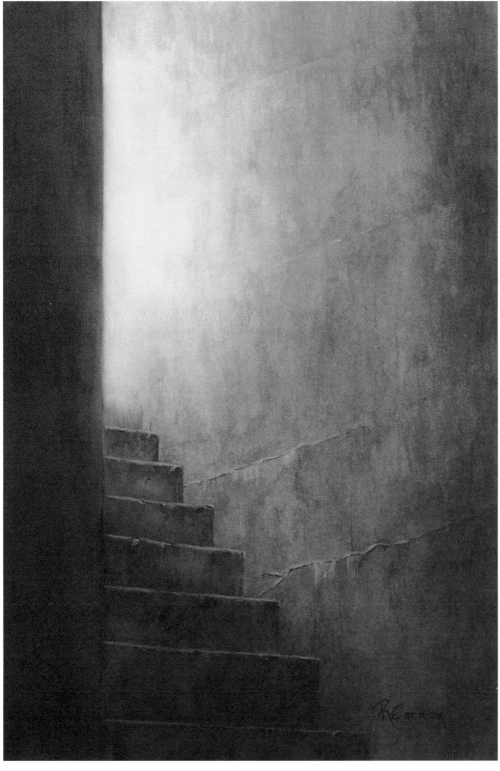

Taking the concept of contrast and values a step further (no pun intended), let's look at this watercolor painting by Ré St. Peter, who used contrast to create a focal point. Notice the contrast where the lightest and darkest points meet on the left side of the painting. Following the rule of thirds, this focal point is off-center and gives the most space to the main subject: the stairs. The light gradually moves through the right side of the painting. This brings balance to the painting so that the viewer is drawn to the details and various colors throughout the painting, creating an intriguing image and a contrast that tells the viewer where to look first. The darkest step brings the eyes back to the left side of the painting, and then the cycle starts over again.

Artist: Ré St. Peter

Negative Space

In art, the term "negative space" refers to the space around or between objects. Anything that isn't the subject can be considered negative space. When creating negative space, the most important rule is to ensure that no two areas are the same.

In this painting by Amanda Schuster, the negative space around the birds complements the subject. A mistake some artists might make is to create equal space between the branches. Schuster was careful to create negative space in different sizes and shapes throughout the painting, however. Instead of keeping the viewer's eyes on certain shapes, this variety inspires the viewer to study the image longer and notice its different elements.

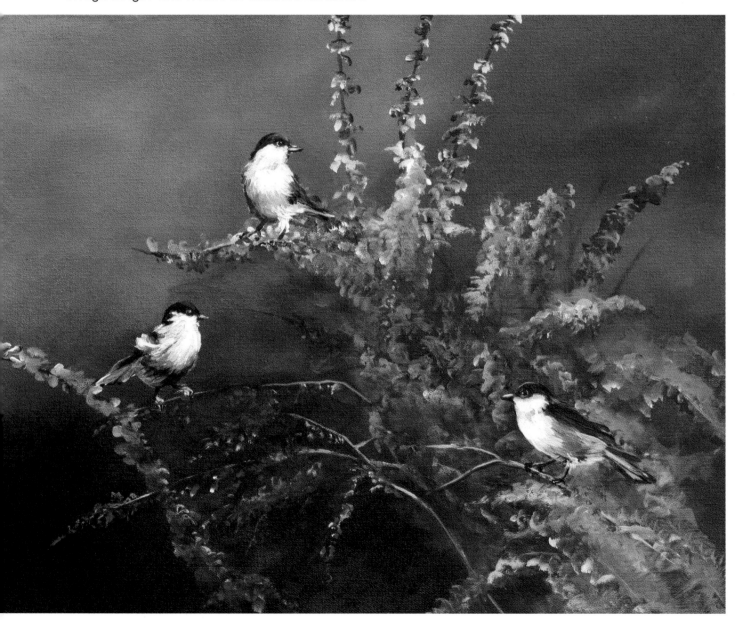

Artist: Amanda Schuster

Positive Space

The positive space in an image is the main subject(s). When creating positive space, you'll want to follow the same rule as with negative space and ensure that no two areas are exactly the same.

Here, Amanda Schuster planned every detail of the space in and around the flower—both positive and negative. She ensured that each flower petal was different. At a quick glance, the petals may look repetitive in shape; however, they all vary in size, shape, and color. The longer you study this painting, the better you will realize the importance of skillfully designing and placing your shapes.

tip

WITHOUT FIRST PLANNING AN IMAGE, IT WOULD BE EASY TO MAKE THE MISTAKE OF CREATING SHAPES IN THE SAME SIZE AND COLOR.

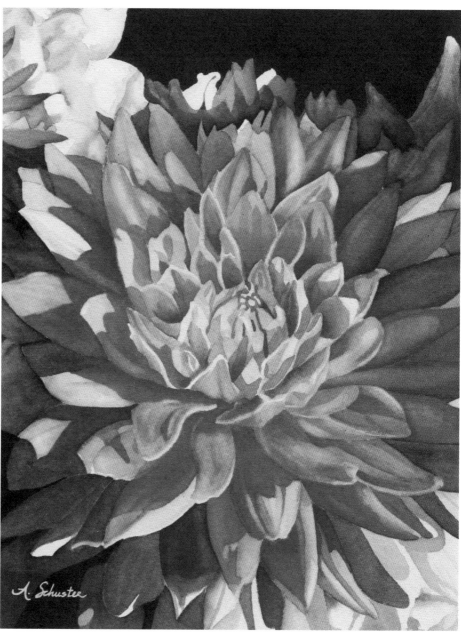

Artist: Amanda Schuster

Perspective

"Perspective" means creating the illusion of three-dimensionality on a two-dimensional surface. To create a strong composition, you must get the perspective right. Perspective is also what gives an image a realistic-looking effect. To achieve this "real" effect, the objects in an image need to be sized correctly, depending on their distance from the subject.

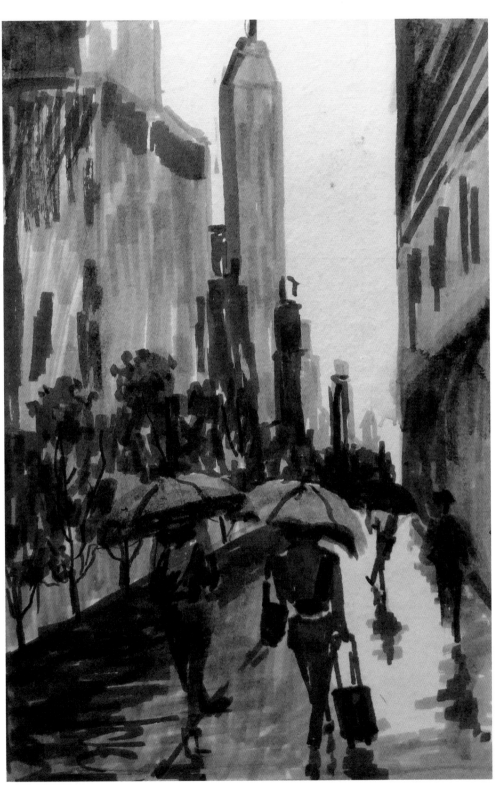

Artist: Lois Haskell

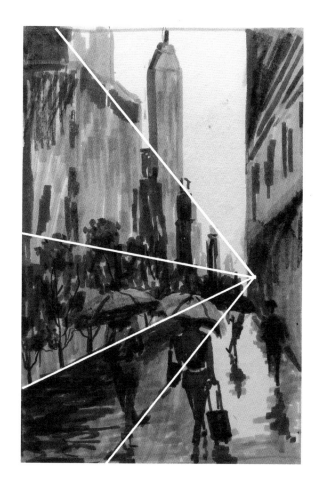

In this sketch, the buildings and trees get smaller as they fade to the right. The taller buildings follow a line or angle that eventually disappears into a vanishing point. Following these angles until they hit the vanishing point creates the illusion of dimension and gives realistic depth to the subjects as they relate to one another.

Notice how the sizes of the figures vary in this sketch; the farther away they are, the smaller they are drawn. This gives the illusion of depth and adds perspective to this image.

A VANISHING POINT IS THE LOCATION IN THE HORIZON WHERE RECEDING LINES DIMINISH OR DISAPPEAR.

When perspective is needed to tell the story in an image, ensure that the elements follow the correct angles into a vanishing point. Try studying artwork or photographs with a strong perspective, and then recreate the angles you see. This will help strengthen your understanding of perspective and ensure that the angles and vanishing point are accurate if there's something in your artwork that doesn't look quite right.

tip

FOR FAR-OFF OBJECTS, USE TINTED OR FADED COLORS, OR ANYTHING LIGHTER THAN THE MAIN SUBJECT, TO CREATE THE ILLUSION OF DISTANCE.

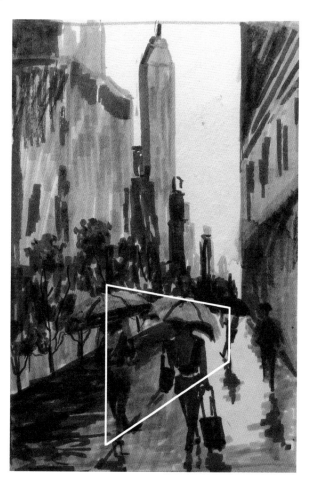

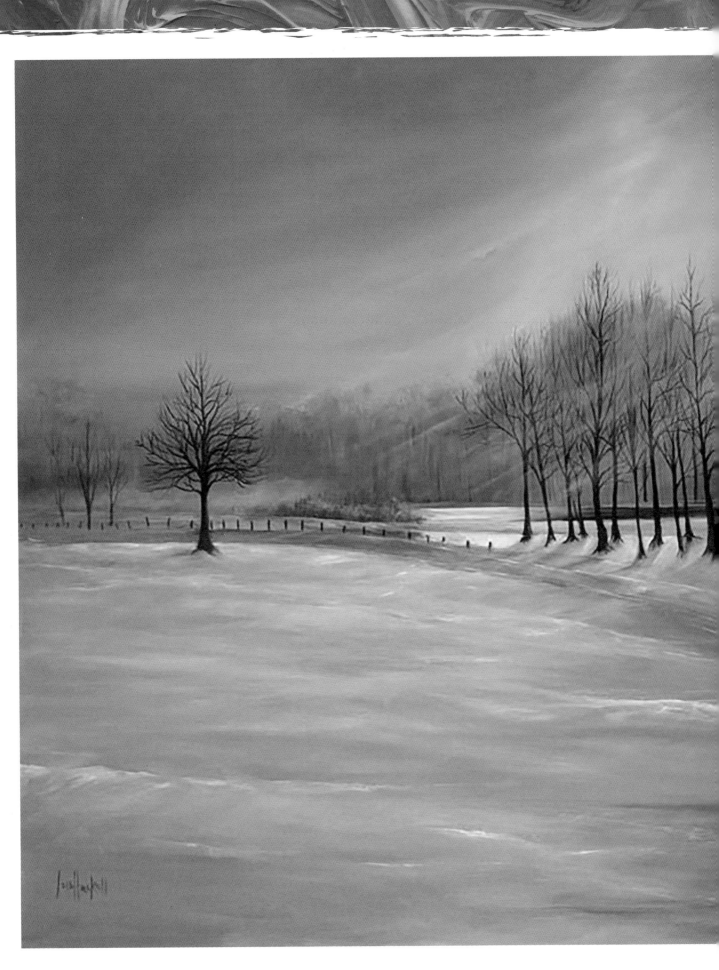

Color

When planning a composition, consider the colors you'd like to use. Color can bring balance and harmony and lead the eye throughout a piece of art. Color is also used to draw attention to or away from a subject, complement and bring unity to artwork, and help strengthen a weak composition.

A perfect example of the use of color to strengthen a composition is this oil painting. The artist, Lois Haskell, had carefully thought out the composition during the sketching process, but when paint hit the canvas, the composition began to get lost as the horizon line moved from the bottom third to the middle of the painting. Typically, dividing a canvas in half isn't ideal.

To save this work of art, the artist used color to create disturbance and the sense of off-centeredness. She darkened the upper-left third of the sunset to carry the viewer's eyes to the horizon line, and the yellow and orange in the sunset moved down in an angle along the road. Notice the lighter values of orange and yellow placed in the bottom corner against the violet complement. This deliberately creates a focal point and draws the eye to the bottom third of the painting.

COLOR CAN BE USED TO ENHANCE A WORK OF ART AND DRAW THE VIEWER'S ATTENTION. IF YOUR COMPOSITION SEEMS TO BE GETTING LOST, CONSIDER WHERE YOU COULD PLACE COLOR TO REGAIN CONTROL OF THE COMPOSITION.

Artist: Lois Haskell

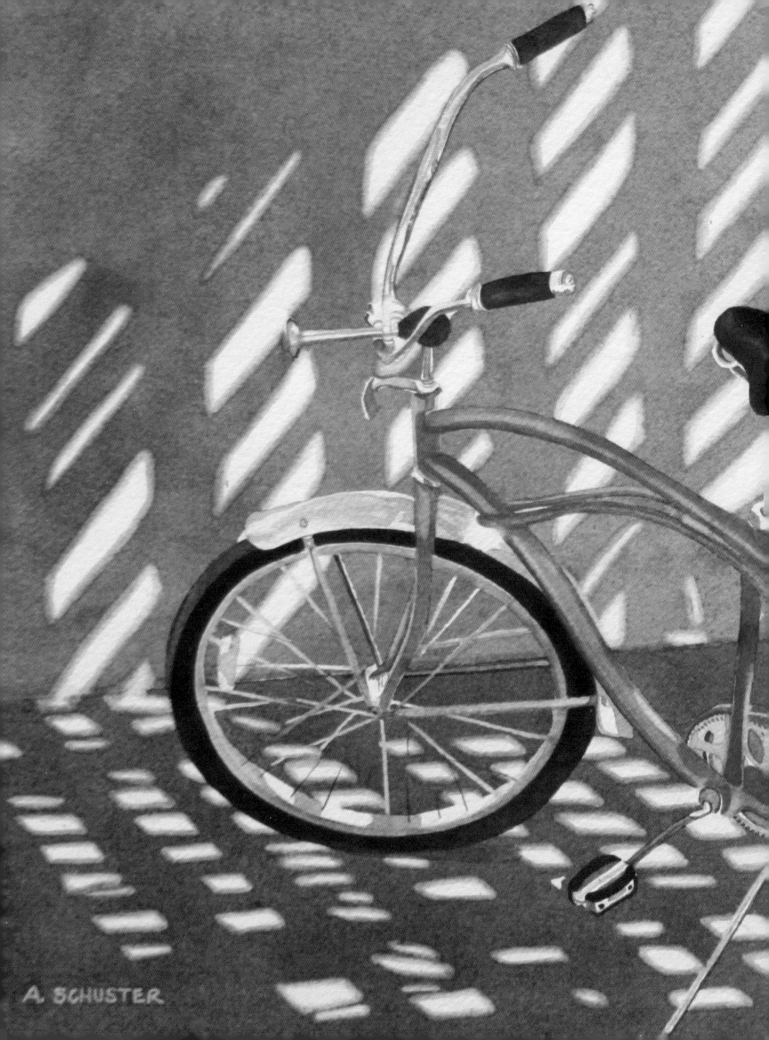

A. SCHUSTER

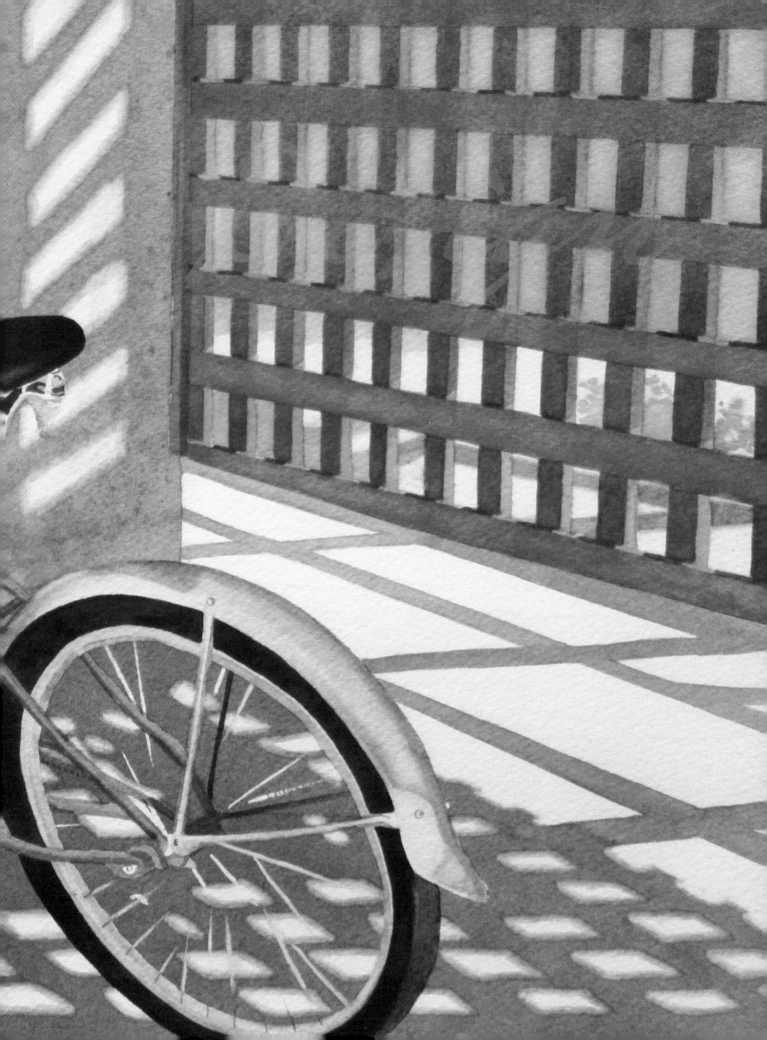

Principles of Design

There are eight principles of design:

- BALANCE
- MOVEMENT
- PROPORTION
- RHYTHM
- HARMONY
- UNITY
- EMPHASIS
- VARIETY

Artist: Lois Haskell

BALANCE

Balance is the placement of visual weights to offset each other, as seen in the example on page 40. The reflection in the lake adds balance and a symmetrical feel to the trees. When an element is balanced by the weight of another element in a painting, it creates a comfortable feeling, putting the viewer at ease.

MOVEMENT

Movement refers to the motion of an object, such as the wavy lines in the reflection of the water. Notice how your eye naturally follows the path of motion when you look at the artwork on page 40. The white in the sky draws the eyes to the white lines in the trees and in the reflection in the water, and then the lighter value of the water on the left side of the reflection draws the eyes back up to the sky.

Artist: Lois Haskell

PROPORTION

Proportion, or scale, refers to the size of elements in an image in relation to one another. In the sketch of the barn on page 41, the grass in the foreground is almost the same size as the barn in the background. The fact that the barn is smaller demonstrates its distance relative to the objects in the foreground.

RHYTHM

In an image, a shape may be repeated, or an element can be repeated with variations. In the sketch on page 41, notice how the pattern in the line of trees is repeated in the foreground grass.

HARMONY

Combining related elements adds a harmonious feel to a work of art. Use color relationships found in the color wheel or similar shapes and objects to add harmony to an image.

UNITY

Unity can be difficult to describe. When a painting or an image has unity, it looks pleasing to the eye. Unity, which creates harmony or wholeness, is achieved when the elements in an image are placed in a way that brings them all together. In the sketch on page 41, the shadows create unity throughout the image.

EMPHASIS

An emphasized area, like the focal point or main subject in an image, draws attention. In the image on page 41, the artist could add emphasis or detail to the barn to bring attention to it, as well as use color and contrast, such as in the light roof against the dark line of trees.

VARIETY

Variety in a work of art can be accomplished using differences, such as by adding colors or various shades of gray, like in the sketch on page 41. A variety of shapes can also be used; notice the angles, sharp edges, and soft rounded areas that create contrast among the shapes in the sketch.

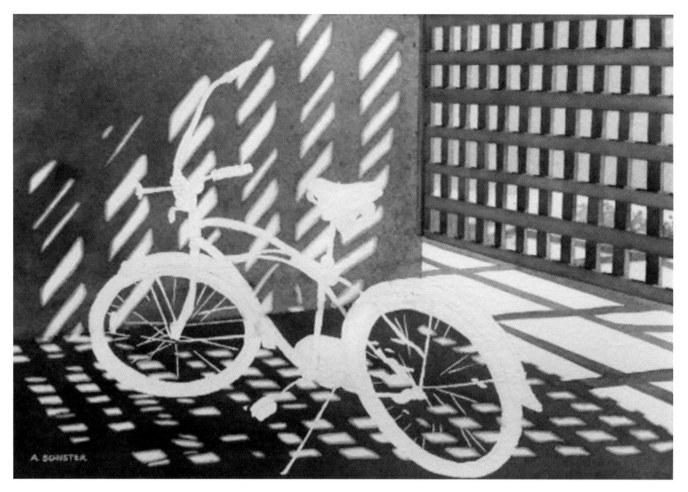

In this watercolor piece, artist Amanda Schuster used the eight principles of design to create reflected light. This required a lot of planning, as watercolor is less forgiving than many other art mediums.

Schuster used masking fluid to create the areas that represent the lightest points in the painting. She created a focal point where the corners of the walls meet and drew the angle of the walls and floor to create depth, proportion, and proper placement of the bike. The contrast between the orange squares and green background create a focal point.

As the light shines through the gate, the viewer is drawn to the reflection on the wall. The carefully placed angles of the reflection draw the eyes down toward the light reflecting on the ground. The placement and shape of the lighter areas create rhythm and movement in the painting, and the reflected light brings unity to the elements in the painting.

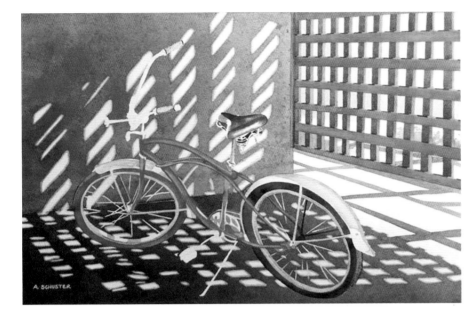

In the second image, the artist introduced a complementary blue color to offset the yellow-orange gate. The careful placement of color creates balance.

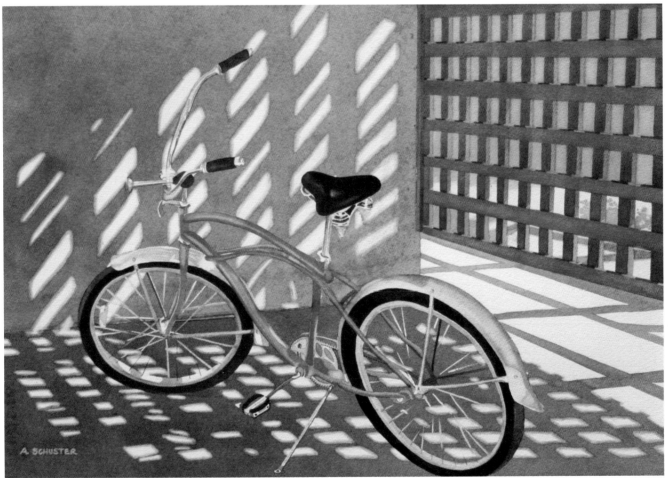

Artist: Amanda Schuster

The third image shows the finished watercolor, in which the artist added an additional layer of yellow over the shadows on the wall. This intensifies the relationship between the colors on the gate and warms the cool colors on the wall and ground, and also makes them look subtler to allow the blue in the bicycle to dominate the image.

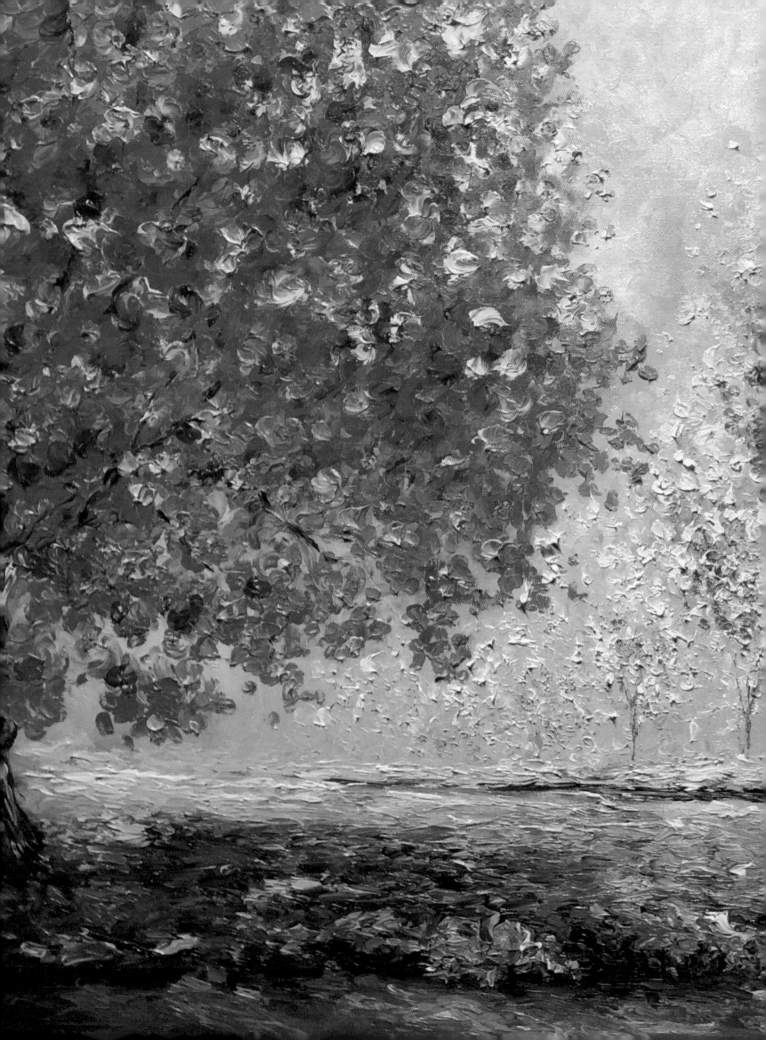

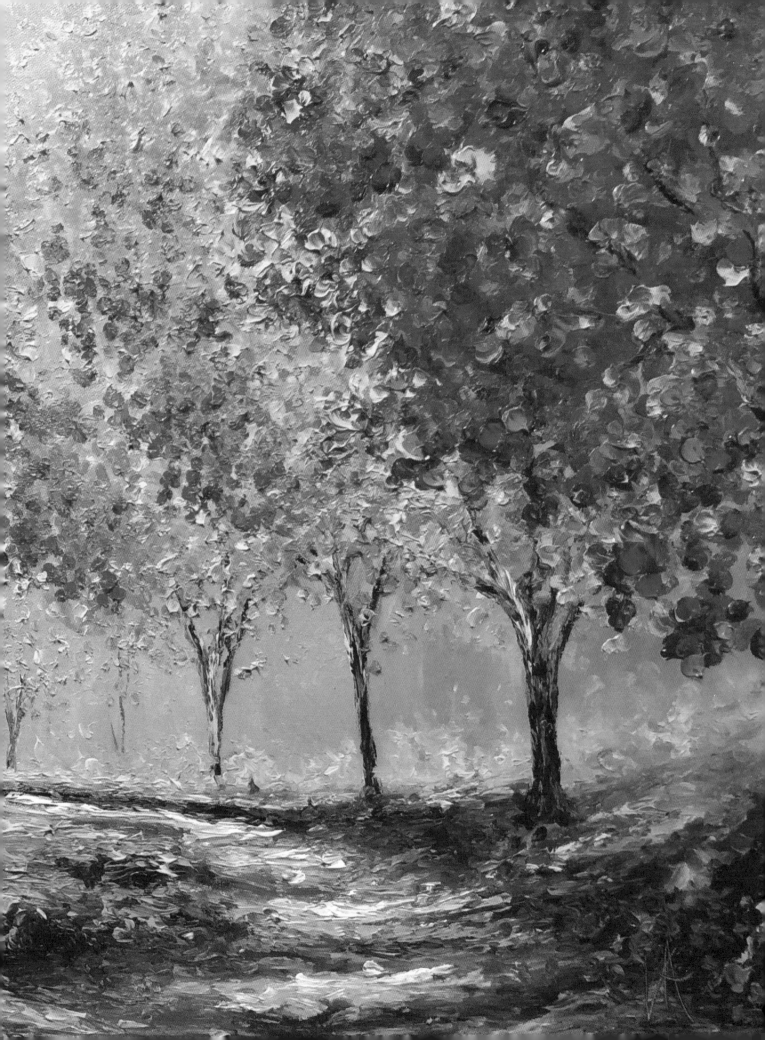

Design Considerations

"GOOD COMPOSITION IS LIKE A SUSPENSION BRIDGE—EACH LINE ADDS STRENGTH AND TAKES NONE AWAY." —ROBERT HENRI, AMERICAN PAINTER

The earlier chapters in this book discussed the principles of design and how to use them to plan a successful composition. Now let's look closely at four common painting subjects—landscapes, portraits, still lifes, and florals—and how a properly executed plan works to create the feeling and idea that an artist wishes to portray.

When designing an artwork, consider the light source, entry point, and structure, and avoid tangents to ensure that there aren't any unwanted distractions in your piece.

LIGHT SOURCE Chosen to translate light and values in a piece of art, the light source helps create the illusion of volume and depth and the feeling of three-dimensionality.

ENTRY POINT This refers to the placement of an object, a shape, or a color used to draw the viewer's eyes to a starting point in a piece of art. Most commonly used in still-life paintings, entry point ensures that the subjects don't look like they are floating or suspended in air. The entry point guides the eyes in the direction that the artist wants the viewer to follow.

STRUCTURE The skeleton that supports the elements of a piece of art.

TANGENTS These occur when two lines touch each other, creating a distraction or disturbing intersection that detracts from the subject.

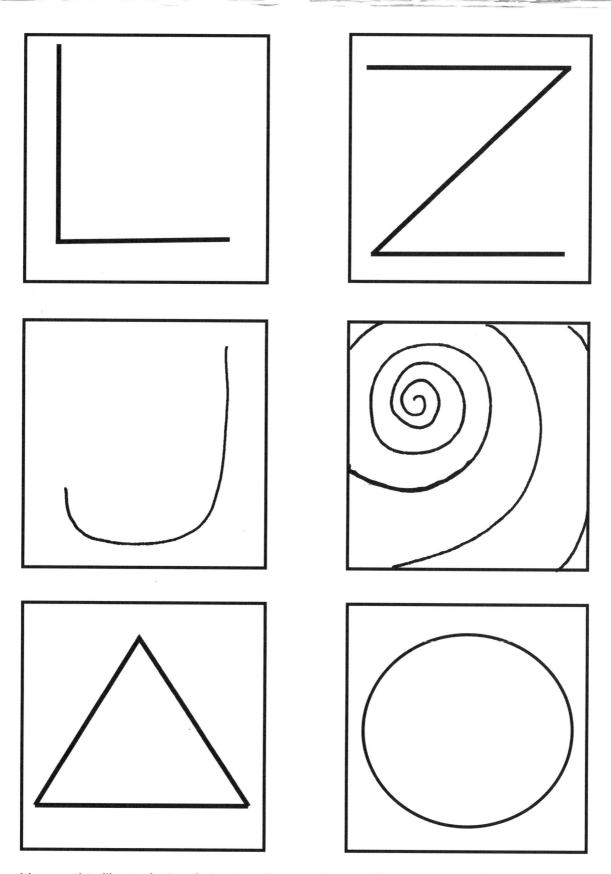

Many artists like to design their artwork around a specific structure, such as an "L," "Z," "J," or "O," or diagonals, spirals, triangles, or circles.

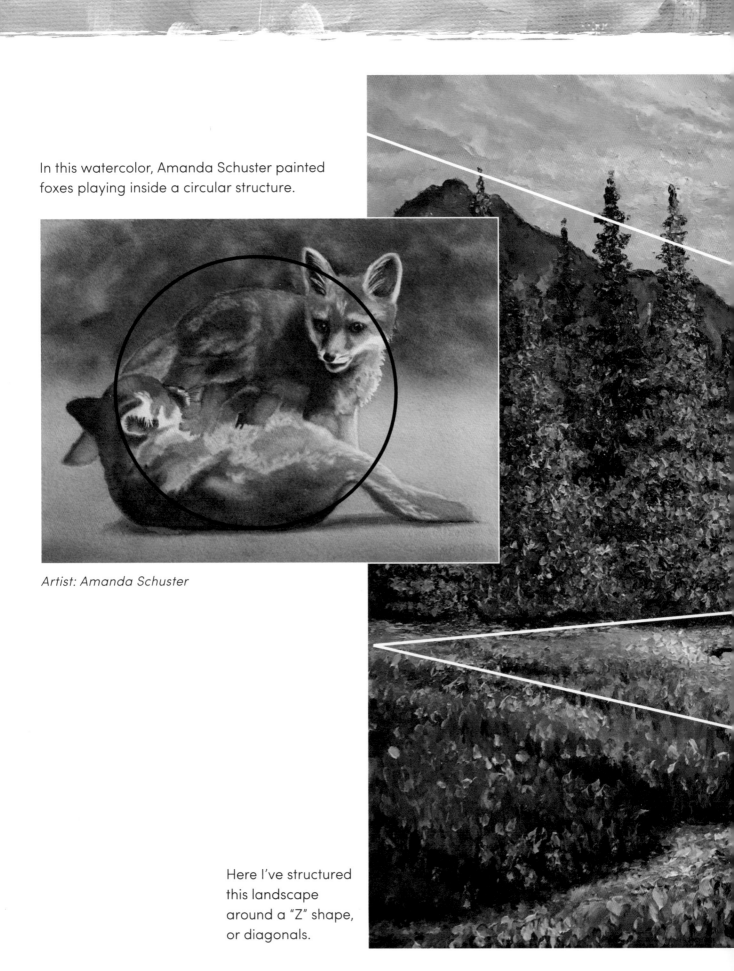

In this watercolor, Amanda Schuster painted foxes playing inside a circular structure.

Artist: Amanda Schuster

Here I've structured this landscape around a "Z" shape, or diagonals.

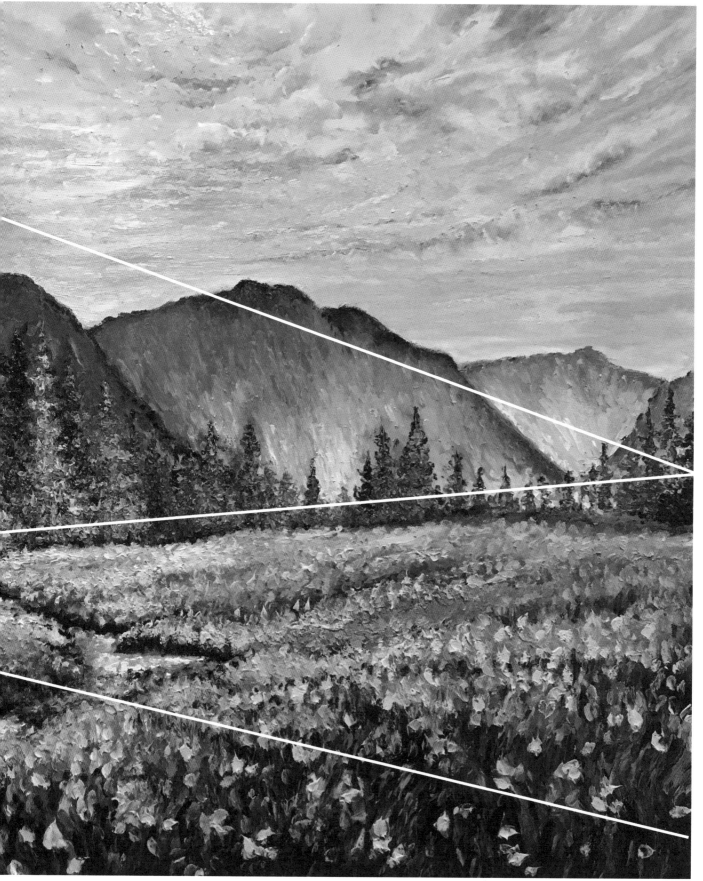

Landscapes

Landscapes are a great introductory subject for beginners, as many of the basic principles of design can be applied to them. Landscapes also happen to be one of my favorite subjects to paint! I enjoy the limitless options, from simple designs to more complex concepts. They can be made impactful using some of the most basic design ideas, as in this example in which I recreated one of Claude Monet's famous landscapes of Argenteuil.

In his painting, Monet placed the horizon in the bottom third and the large section of trees in the right third of the painting, creating balance and setting the perspective through a simple J-shaped composition. Monet often repeated this design concept, placing the horizon line in the bottom third of the canvas and a vertical object on the right or left third of the painting.

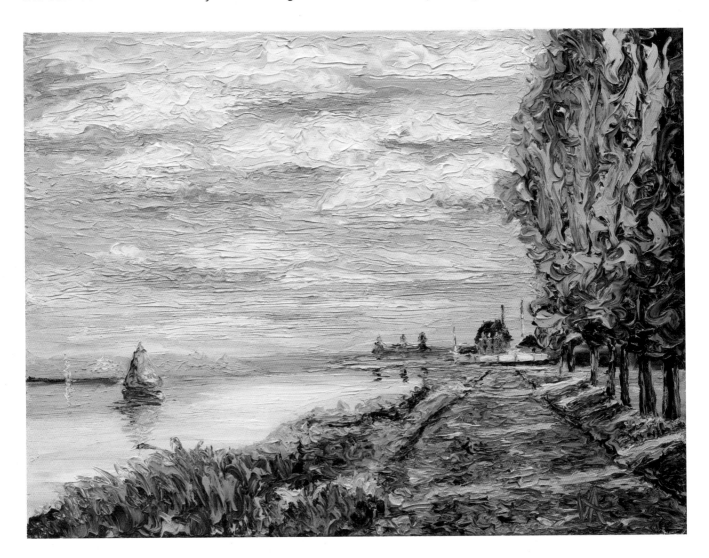

One of the keys to being purposeful with your journey as an artist is mastering a design and structure and finding ways to recreate an existing concept using different subjects. In the next example, a painting called *Shaded*, I used the J-shaped design concept with my own subjects. The structure is similar to the one inspired by Monet's painting (left), but I repurposed the design using inspiration from my own surroundings.

tips

LOOK AT IMAGES AND YOUR ENVIRONMENT, AND YOUR ARTISTIC POSSIBILITIES WILL BECOME ENDLESS. THEN RECREATE THESE INSPIRATIONS ON CANVAS, KEEPING IN MIND THE STRUCTURE OF DESIGN AND YOUR OWN CURIOSITY ABOUT THE WORLD AROUND YOU.

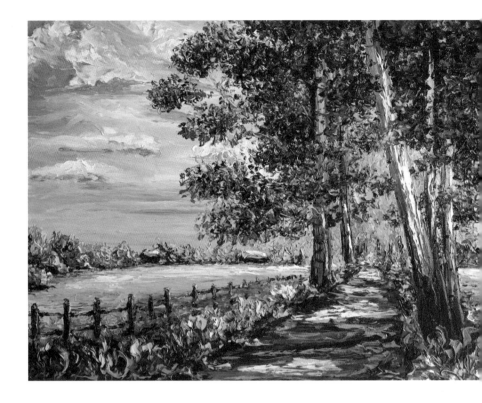

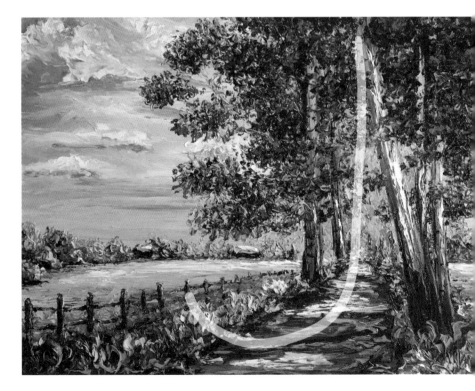

tip

STUDY MASTERS LIKE CLAUDE MONET, VINCENT VAN GOGH, EMILY CARR, AND PIERRE-AUGUSTE RENOIR, AND IDENTIFY THE PLANS OF DESIGN IN SOME OF THEIR PIECES. TRY TO RECREATE THEIR WORKS UNTIL YOU FEEL COMFORTABLE USING THEIR DESIGN TECHNIQUES IN YOUR OWN IMAGES.

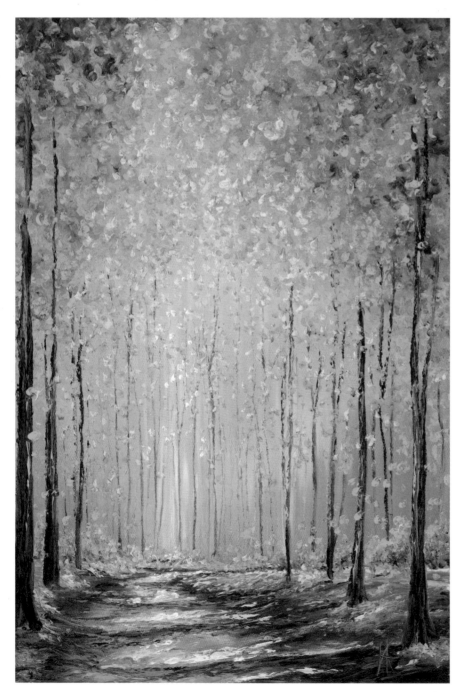

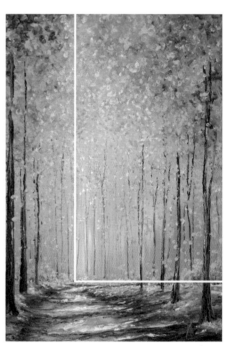

An L-shaped composition leads the viewer's eyes around an artwork in thirds, creating a feeling of peace.

BALANCE & STRUCTURE

I created this landscape using an L-shaped structure. Notice that I placed the horizon line in the bottom third of the canvas, while the trees receded in a light pathway that falls on the left-third portion of the canvas, creating an "L" shape. This design harmonizes and balances the elements in a subject, and it gives me a guideline to follow when I recreate the image on canvas.

Remember that an odd-numbered grouping of objects keeps an image from looking too symmetrical and attracts the viewer to stay and study the image. Painting the trees in an even number or too symmetrically would cause the painting to lack interest.

Also, notice the harmony between the cool greens and blues and the warm yellows and browns. The placement of the warmer colors is purposeful as well; I used them to draw the viewer's eyes toward the pathway and the trees that frame the bright background.

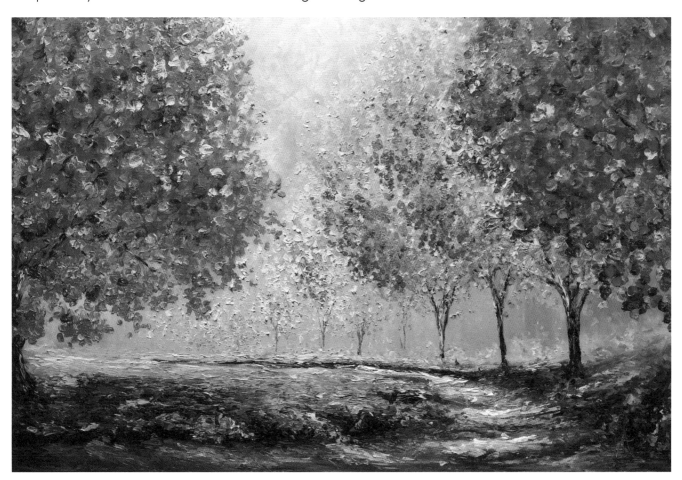

USING A VANISHING POINT

In this example, the angles create perspective using a vanishing point (page 35). Again following the concept of an L-shaped design, I placed the horizon line in the bottom third of the canvas; the tree on the left fills the space in the left third of the canvas, and the other trees recede into the distance. By planning ahead to use a vanishing point, I sketched in the angles that the tree line would follow to ensure that I portrayed the right perspective. The pathway and the tree trunks also use the same vanishing-point concept to support this perspective.

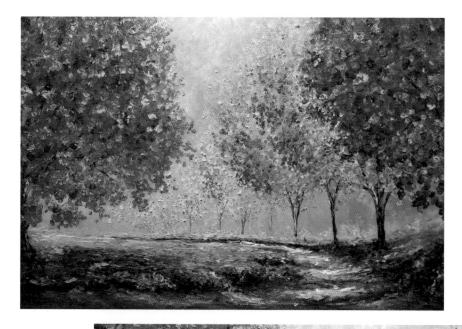

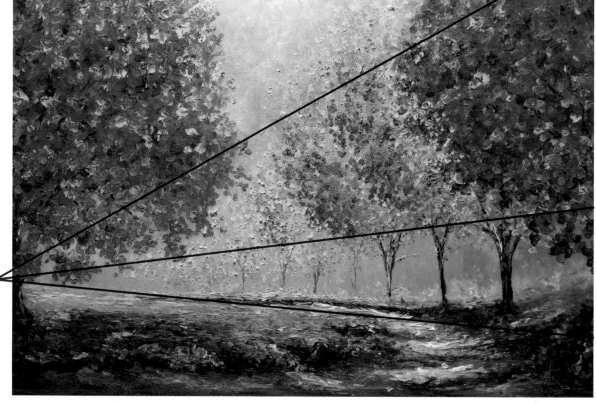

Vanishing Point

ANGLES & COLOR

The next example is a little more complex, as the design uses not only the principles of design but also an emphasis on color to define the shape and composition. The horizon is still placed in the bottom third of the painting, giving most of the canvas to the star of the painting: the fall foliage. The bright pathway forms a focal point where the bottom and left thirds of the grid (following the rule of thirds; see page 10) would intersect. The angles of the shadows move the viewer's eyes toward the bottom left of the canvas, where bright reds pull the eyes from the vibrant foliage in the top two-thirds of the painting and into the "Z" shape emphasized at the top. Shades of dark violet in the lower-left corner capture the eyes and move the viewer back to the top of the painting deliberately. The angles are not straight lines to create interest and prevent distracting from the other elements.

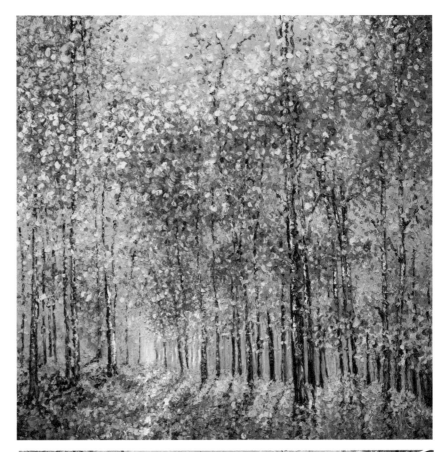

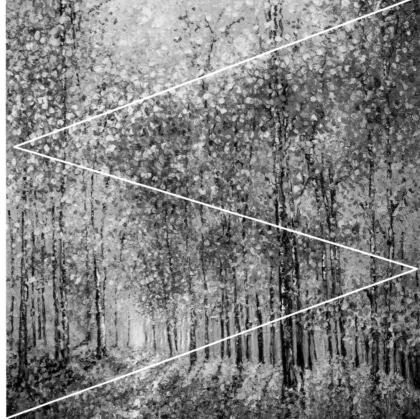

A Z-shaped composition draws the eye to each side of the painting.

IMPROVING A PHOTO

This landscape shows how an artist can use a photograph as inspiration but then detour from it to make the composition more pleasing. Notice that in the photo below, the pathway ends in the middle of the picture. The artist, Lois Haskell, made a thumbnail sketch, in which she moved the pathway. She used that sketch to create the painting.

She closely represented the colors and elements in the photo; however, that subtle change in placement of the pathway turned this ordinary photo into an extraordinary painting.

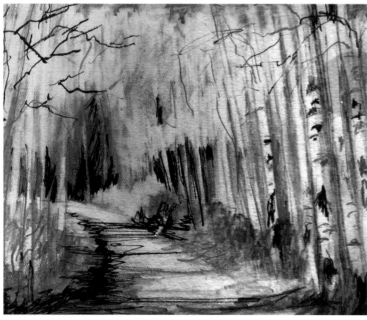

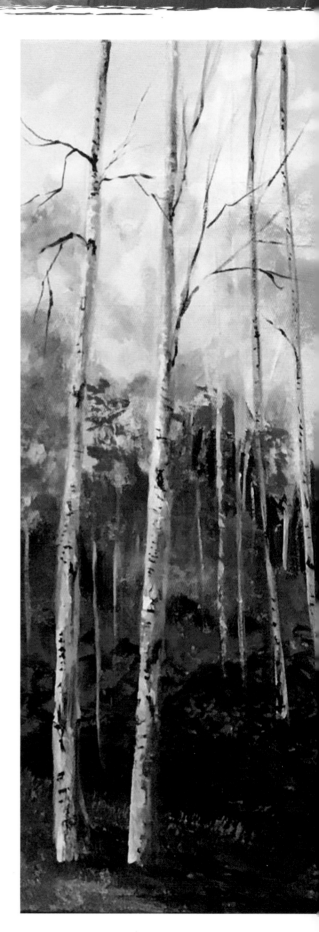

Artist: Lois Haskell

58

LANDSCAPE DOS AND DON'TS

• **DON'T** place the horizon line in the middle of the canvas.

• **DO** avoid tangents. An example of a tangent in this painting is where the roof touches the horizon line. This makes for a less pleasing composition and gives the appearance that the roof is part of the horizon line.

• **DO** apply the rule of thirds and devote two-thirds of the painting to the main subject. For instance, if you're painting a landscape and the clouds are the main subject, give the clouds the majority of the space (two-thirds), while the foreground takes up only one-third.

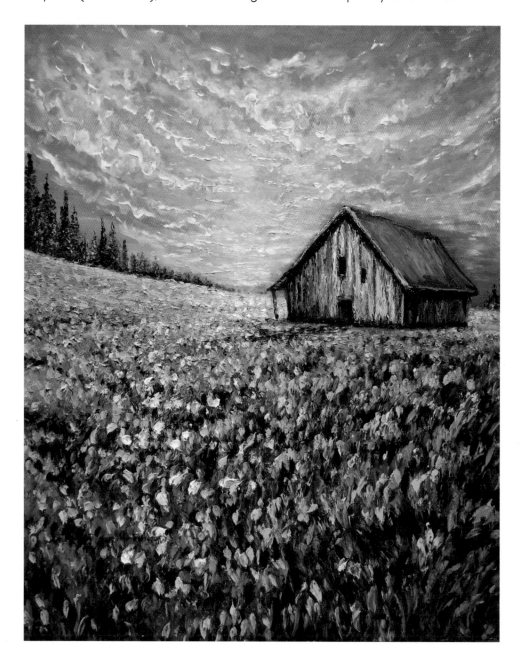

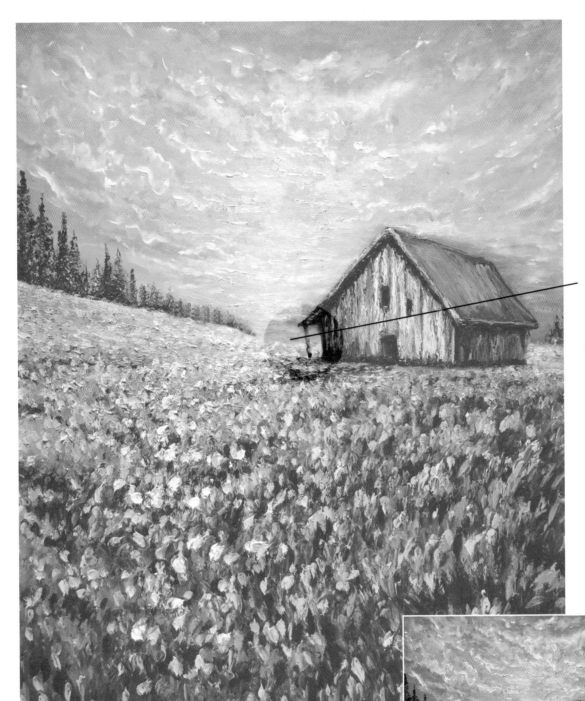

Do create a separation between the horizon and the elements.

Don't place the horizon in the middle of the canvas.

Portraits

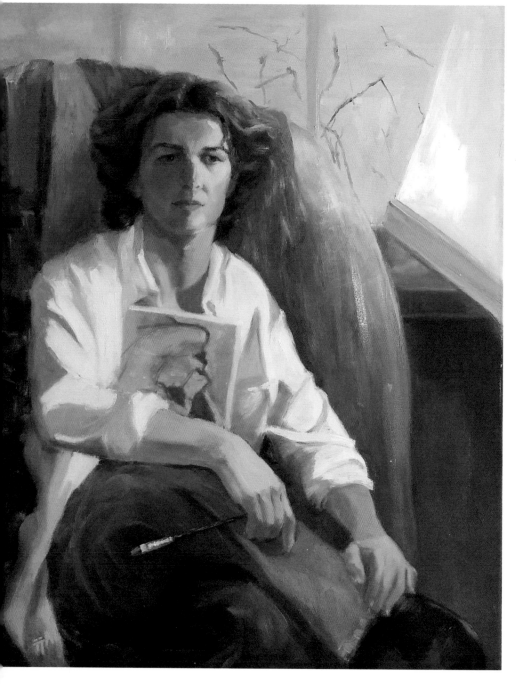

Portraits have a reputation as one of the most intimidating subjects to paint; however, if broken down into shapes and design, they can also be one of the most rewarding. When creating portraits, it's important to feature a light source to show the density of a subject, as well as to define points of interest and depict values. Carefully place the angles to create movement and frame your subject.

Artist: Irena Jablonski

LIGHT SOURCE

In this portrait, artist Irena Jablonski used a simple triangular design to add structure. The subject's arms are proportionate to his body and placed to deliberately draw the viewer's eyes from the young man's face and down his arm to the hand that rests on his foot. The hands are positioned relative to one another so that the viewer follows them upward toward the knee, and continues to move up to the bent arm. The eyes then naturally move up toward the shoulder and back to the face.

The light source in the upper-right portion is a key element of this painting. The highlights help support the angles and carry the viewer's eyes as the artist intended.

Similar to the rule of thirds, the subject is placed in the left third of the painting, rather than in the center. The angle of the hands mirrors the angle of the wood-framed window in the background so that the angle of the window pulls the viewer's eyes to the back of the chair and, therefore, the top-right third of the canvas, creating a focal point.

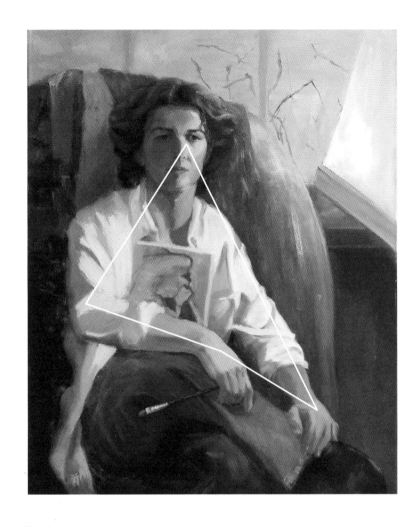

EACH ELEMENT IN THIS PAINTING WAS PLACED WITH PURPOSE TO SUPPORT THE SUBJECT AND INITIAL STRUCTURE OF THE TRIANGLE.

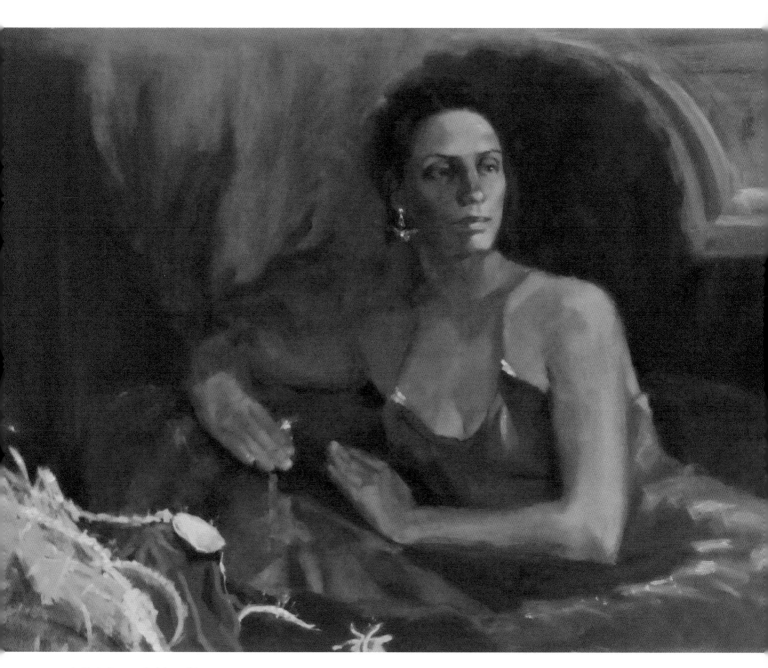

Artist: Irena Jablonski

ENTRY POINT

Looking at another portrait by Irena Jablonski, the artist used the same triangular structure as on pages 62 and 63, but with a slightly different design. The light source in the upper right creates distinct highlights that are both intriguing and bold. The subject's entry point in the bottom-right portion of the canvas is deliberate; the artist wants the viewer's eyes to start there and follow the angles and placements of the highlights throughout the painting.

The architectural shape in the background uses negative space and shape to draw the eyes back to the main subject. The bright highlights on the dress, nails, and earrings offset the white in the bottom-left part of the canvas. Complementary orange and blue colors create harmony, balance, and unity throughout the painting. Notice how the cool blues and greens soften the warm colors in the subject and are mirrored in a reflection above the subject's shoulders.

This may seem complex, so imagine that you are the artist. As you plan the placement of your elements, you will notice certain tangents and move or adjust lines as needed. Shape the negative space to complement and support your subject. When introducing a color, plan to place it in at least three sections of your piece to balance out the color, creating unity between your subjects.

WHEN YOU USE THE ELEMENTS OF DESIGN AS A FILTER, THEY WILL ALL SEEM TO COME TOGETHER AND THE COMPLEXITY OF PLANNING A PIECE WILL SEEM TO FADE AS YOU LOOK AT EACH SECTION INDIVIDUALLY.

USING COLOR

Here, Irena Jablonski placed the light source in the upper left, creating a glow over her subject that helps support the story and feeling of this young lady reading a book. The entry point is the orange book cover draped over the subject's arm, which directs the viewer's eye to the next element in the painting. Follow the light where it hits the shoulder, and you will see the other highlights following a circular pattern toward the subject's cheek, hand supporting her face, highlight on the book cover, and finally, the hand resting on her leg. The highlights in the fabric draw your eye back up to the arm and then to the shoulder, where you started. This masterful design forms the core structure of the painting, and the remaining placements of color, highlights, and values support this circular structure.

The colors used in this painting are complementary oranges and blues, with a muted red that grabs attention as the focal point. Notice how the placement of the book also follows the rule of thirds where it is placed in the bottom right third of the painting.

Consider too that the artist used red highlights to balance the red in the book. This was done so that the viewer's eyes wouldn't stop there; by placing red in other areas on the canvas, the artist ensures that the viewer's eyes are drawn to other elements as well as they move and follow the placement of the red.

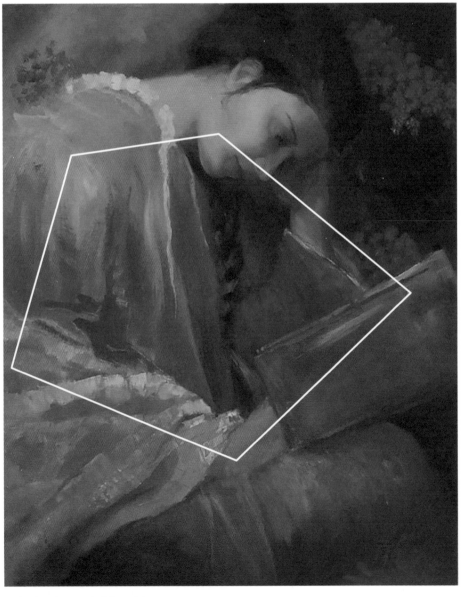

Artist: Irena Jablonski

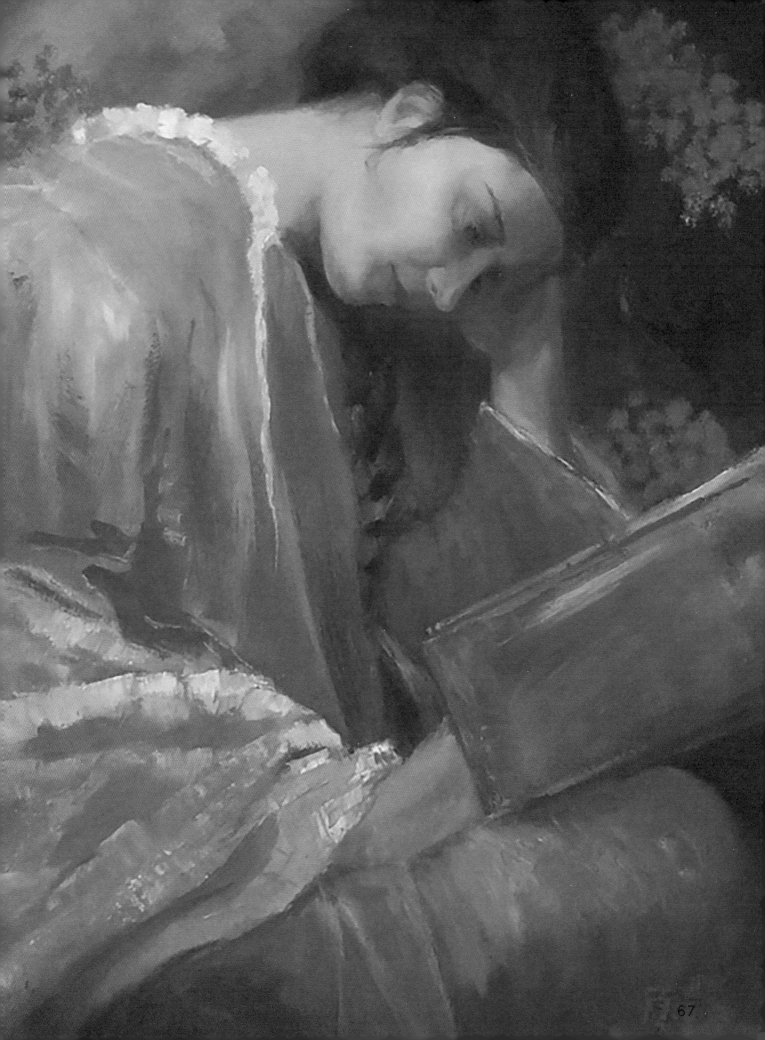

DESIGN

In this last portrait example by the same artist, the design is a bit more complex and features a more structured, angular composition that combines a triangular and circular structure. The light source in the upper left defines a triangle between the subject's shoulders and face, while the angle of the arms frames the subject and pulls the viewer's eyes from the focal point created by the contrast between the bright flowers and the darker foliage.

For a great example of how the artist avoided a tangent, notice the angle of the negative space and the shapes in the background. Placing them higher would have distracted from the subject, making the head appear to be part of the background. The artist's placement of the angle gives the illusion that the subject's head is in from of the other elements and away from the background.

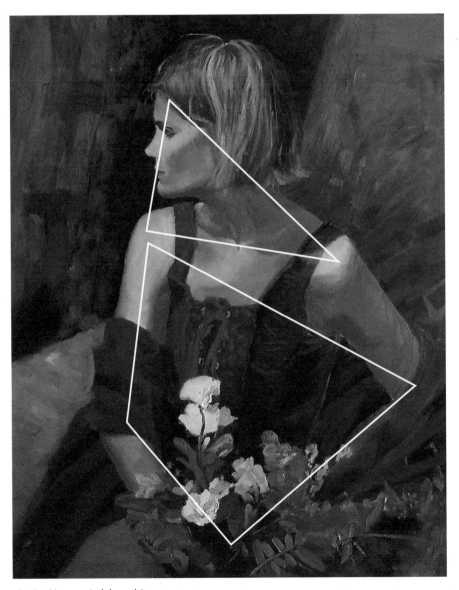

Artist: Irena Jablonski

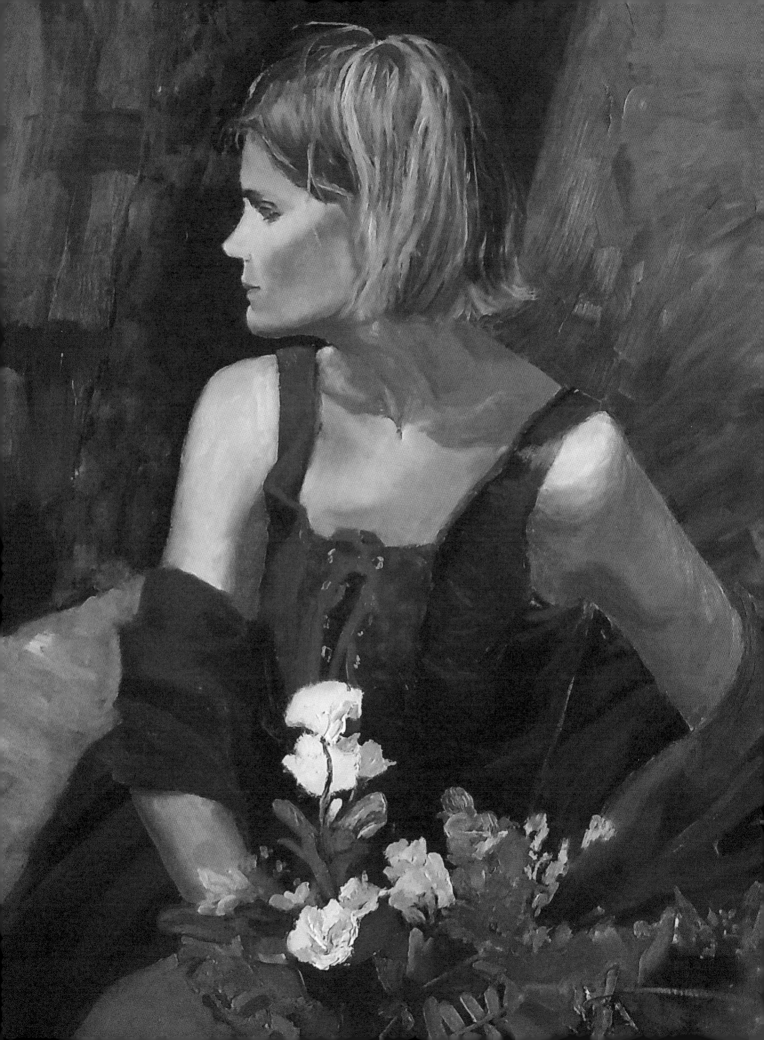

THE RULE OF THIRDS

This painting was done using a reference photo. The artist used the rule of thirds (see page 10) to plan his piece and chose to remove certain elements from the photo, as they wouldn't add value to the final image.

In this very simple design, the subject is the focal point and offers a great example of positive and negative space. The artist placed the subject on the left third of the canvas and ensured that all of the shapes in negative space were different. The proportions used within the face were carefully designed as well. In the original picture, the eyes weren't easily seen, but the artist chose to make them more dominant in his painting. This adds a human element, as the subject's eyes capture the viewer's attention.

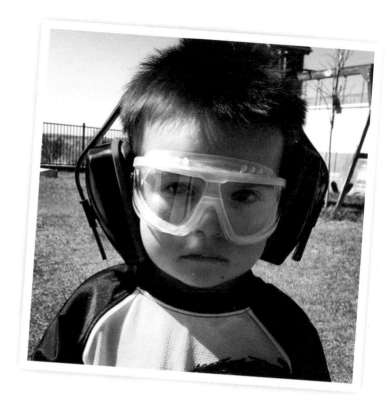

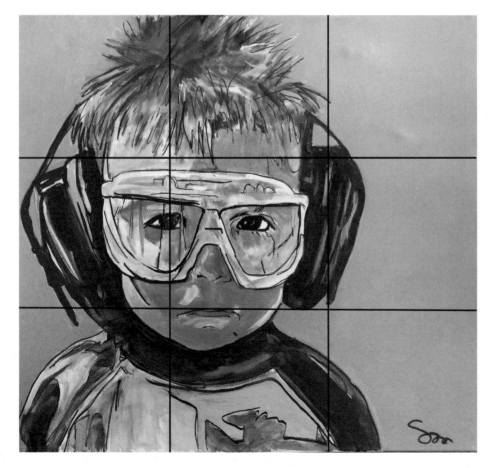

The artist used the blue highlights seen in the goggles in the original photo and showed the importance of carrying colors into other places as well. If this weren't the case, the viewer would focus on a single color instead of letting the eyes move around the painting. The artist also used highlights of blue seen in the photo of the goggles throughout the painting.

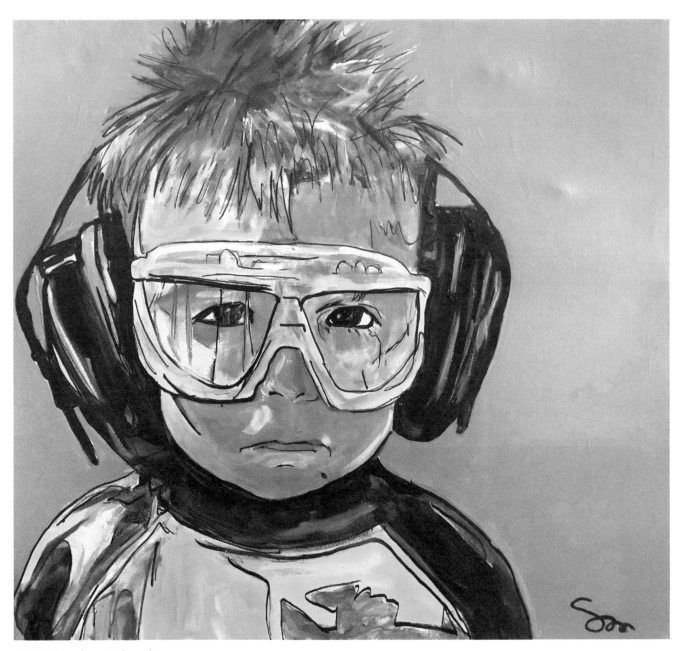

Artist: Stephen Valverde

 CARRY COLORS THAT ARE INTRODUCED TO THE PIECE INTO OTHER PLACES AS WELL.

Still Lifes

A still life is a painting featuring an arrangement of objects, usually including fruit, flowers, and another object that creates textural contrast, such as glass, a porcelain vase, or a shiny metal bowl. Still lifes are fun to paint and can provide artists with a good study of lights and darks, as well as shapes.

When designing a still life with a strong composition, one of the most important tips is to include an entry point, or an object or a shape placed near the edge of the painting that captures the viewer's attention and draws the eyes toward the other main subjects. Without an entry point, a still life may look like it's floating.

ENTRY POINTS

Lois Haskell's still life of green apples exemplifies how important an entry point can be. Without this key element, the subject would appear to float. Notice how the artist used the colors in the entry-point flower to carry the viewer's eyes throughout the subject. The design follows a circular structure as you look at the white flowers and white highlights on the apples. The artist used cool green shades in the apples and in the reflection of the foliage on the table too.

With entry point:

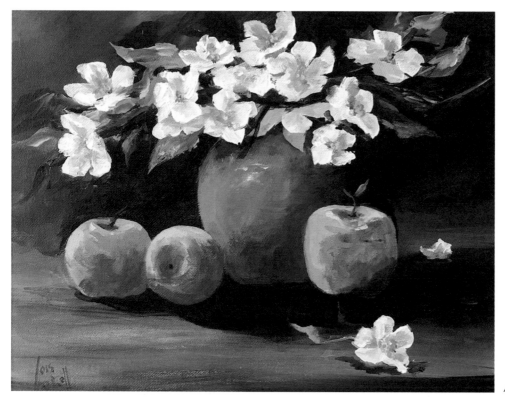

Artist: Lois Haskell

Without entry point:

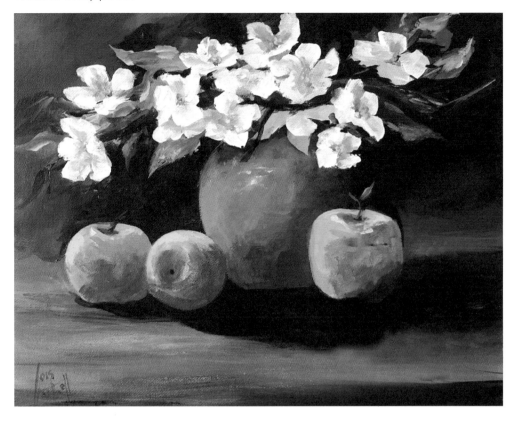

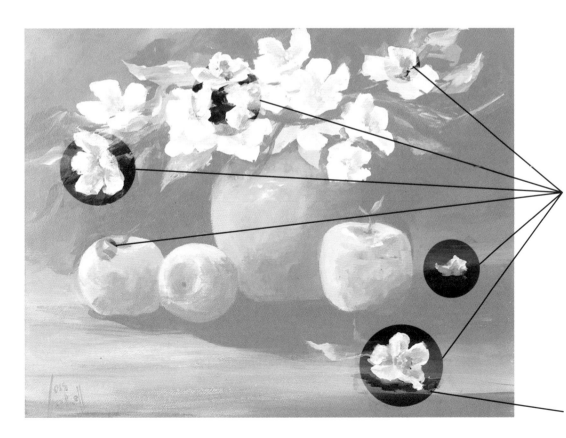

Draw the viewer's eyes from the entry point and carry them through the painting.

Entry point

POSITIVE & NEGATIVE SPACE

Arranging common items found in your home is an easy way to test how well you understand the placement of subjects in order to create a successful composition. Make sure your arrangement features various sizes and shapes, and try grouping the objects in threes. A good light source is important, as it will help exaggerate shadows and reflections.

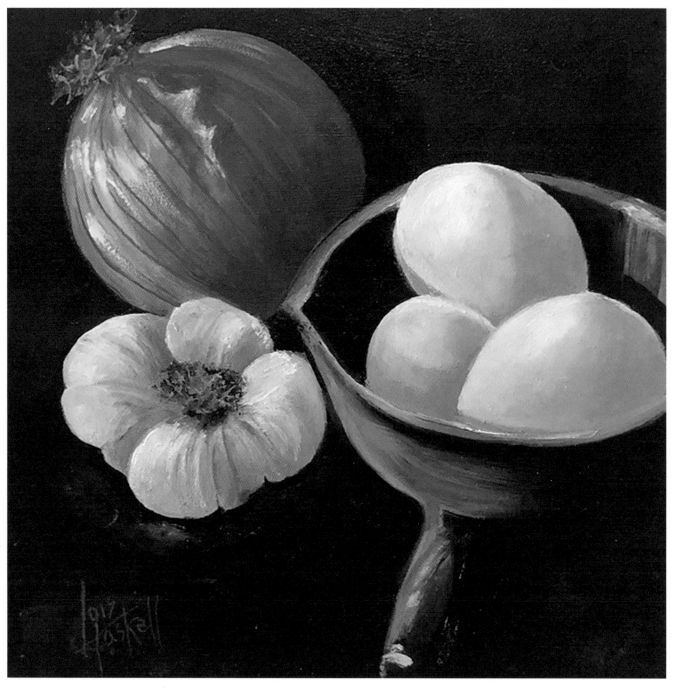

Artist: Lois Haskell

This still life includes common everyday items and will test your ability to properly paint positive and negative space. It features a simple triangular design with the handle of the pan cleverly placed as an entry point. The bright orange on the onion is carried into the garlic, eggs, and handle as a highlight. It also reflects onto the table to soften the dark background. White is used similarly.

The use of negative space helps create dimension and keeps the painting interesting. Notice how no two subjects or spaces are equal in size. The objects are carefully placed so that they meet or intersect without creating awkward lines or tangents.

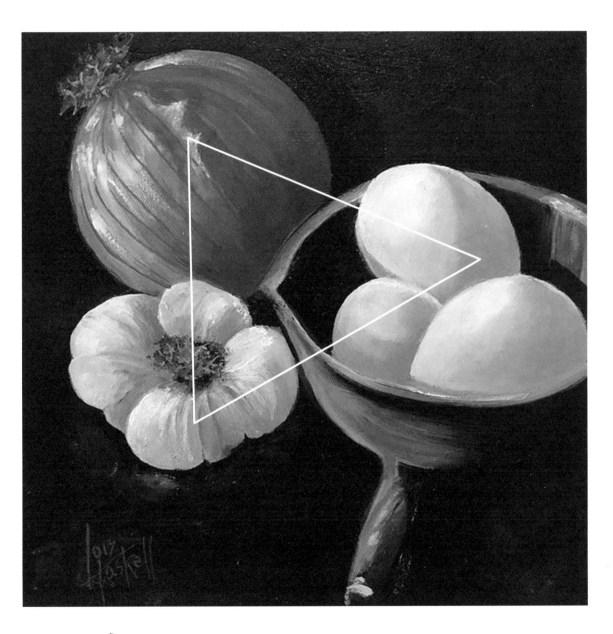

 THE SUBJECT'S PLACEMENT IS OFF-CENTER; THIS IS THE KEY TO CREATING A CAPTIVATING COMPOSITION.

VALUES

A successful still life displays contrast and the use of values. In the painting on page 77, the proper values are captured, creating a strong contrast between the subjects. The lightest values, which are represented in the tablecloth, carry into the brightest highlights in the flowers. The oranges and daisies represent the medium values. The vase and the darkest part of the flowers display the darkest values. By placing a dark background near the edge of the table on the left side of the painting, the darkest shape in the vase is offset.

WITHOUT THIS IMPORTANT PLACEMENT OF VALUES, THE PAINTING WOULD APPEAR HEAVIER NEAR THE RIGHT SIDE OF THE VASE.

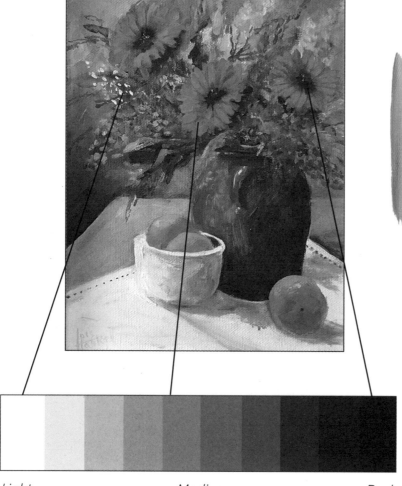

ENJOY GOING ON A SCAVENGER HUNT IN YOUR OWN HOME TO CREATE A STILL LIFE SIMILAR TO THIS HUMBLE PAINTING!

Light *Medium* *Dark*

Artist: Lois Haskell

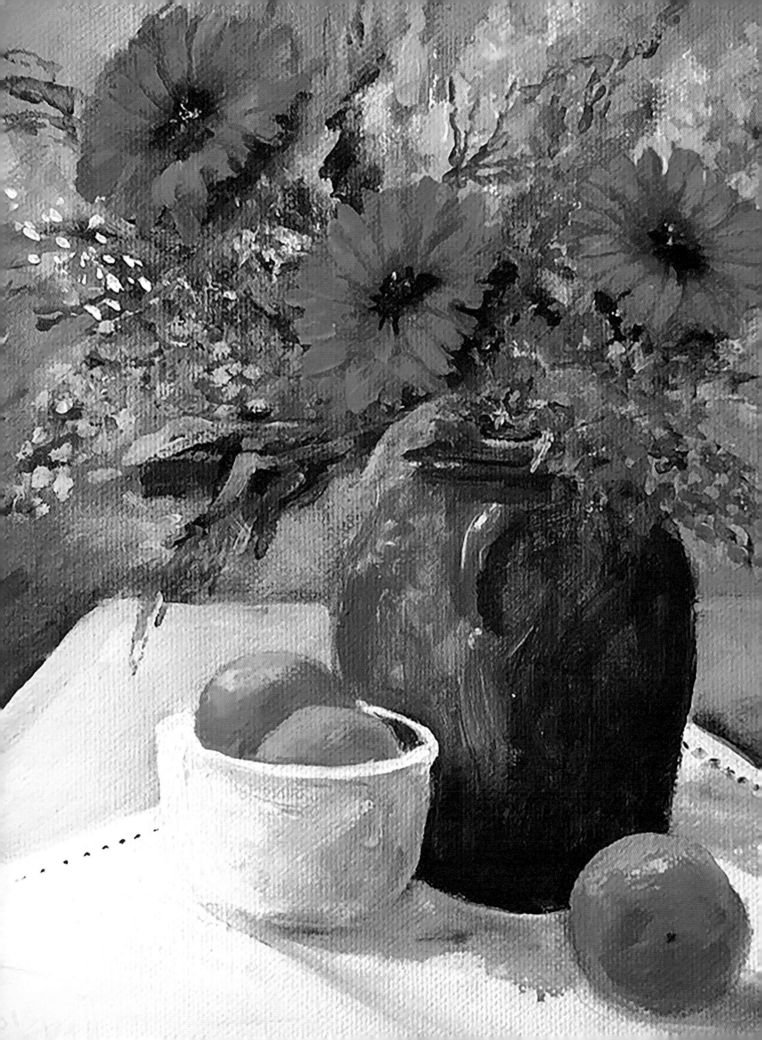

TANGENTS

This still life appears simple, but as you dissect its composition, you will notice that there's a lot happening in the piece. The composition features a circular structure, using the color orange to carry the viewer's eyes between the elements. The angle of the flowers pointing downward draws the eyes toward the orange slices on the table, and the shape of the oranges creates an angle pointing upward toward the vase and the foliage. Note that there are odd numbers of flowers and fruit. Even numbers would make the subject look too simple.

Artist: Lois Haskell

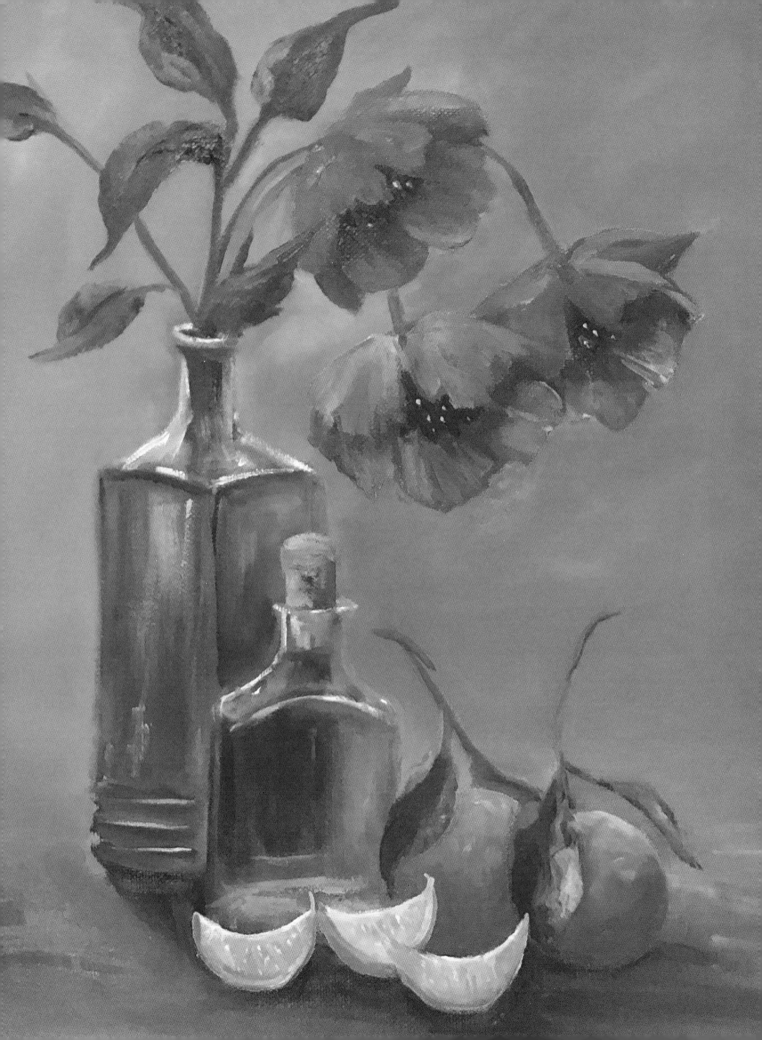

The potential tangent at the bottom of the painting offers an opportunity for improvement. The two orange slices align almost perfectly where they meet, creating a spot where they touch. The artist noticed this and adjusted the values to create an opening so that the oranges wouldn't meet at one exact point.

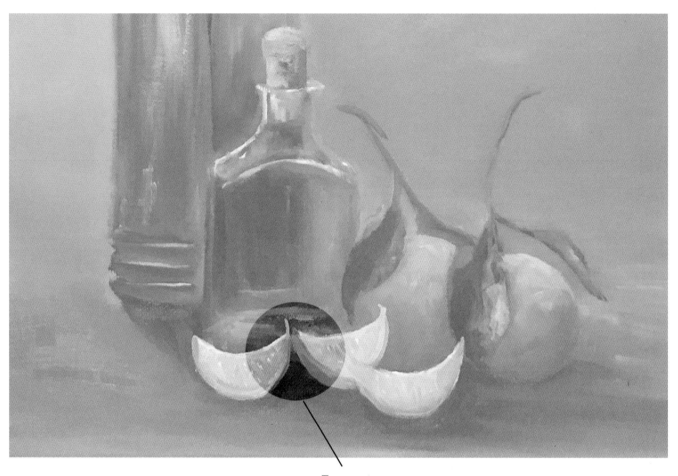

Artist: Lois Haskell

Tangent

To improve her painting, the artist added definition to the two oranges, making the appearance of one in front of the other appear more dramatic. You can do this by darkening the edge of the orange that sits behind the other and adding a bright highlight to the orange in front.

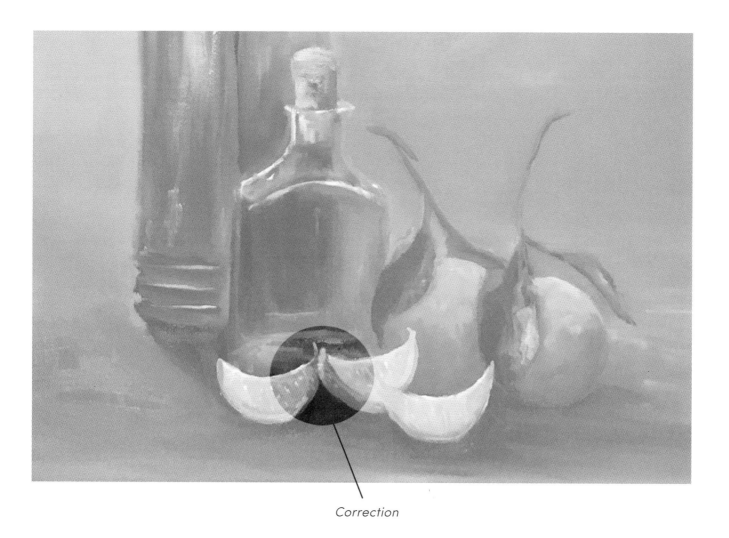

Correction

KNOWING THE GUIDELINES AND LEARNING HOW TO CORRECT MISTAKES IS PART OF BUILDING YOUR CONFIDENCE AS AN ARTIST.

Florals

Floral paintings can be simple yet complex at the same time. They are simple in that they are generally composed of one subject: flowers. What makes them complex is that they feature suggestion and purposeful placement of that subject, both of which require going beyond just painting a bouquet.

I painted the sunflower piece on page 85 as a study of French artist Claude Monet's *Bouquet of Sunflowers*, which uses the placement of the flowers, positive and negative space, and color choice to create a successful, attention-grabbing composition.

COMPOSITION STYLES

There are several composition styles to choose from when creating a floral painting.
Some of the most popular ones include:

VERTICAL The height of the flowers and/or foliage is greater than the width of the subject.

HORIZONTAL The placement of the flowers or branches portrays a spray horizontally, usually in a small or low container.

TRIANGULAR Flowers are arranged in a triangular shape.

SPIRAL Using the golden ratio (page 84) as a guideline, flowers are placed in a spiral sequence.

GOLDEN RATIO

What is the Golden Ratio, or the Golden Mean, as it's often called?

For those of us who are not mathletes, I'll summarize this rule in a broader sense. This ratio or calculation is what the human body, trees and some other natural elements, and even waves in the ocean have in common. Painters, sculptors, and architects use this ratio in their designs. Basically, it's a mathematical calculation to mimic the proportions found in nature.

For those who are good at math, the Golden Ratio is approximately 1 to 1.618. It is a mathematic principle dividing a line into two parts, so the longer section divided by the shorter section is equal to the whole length divided by the longer of the two lines.

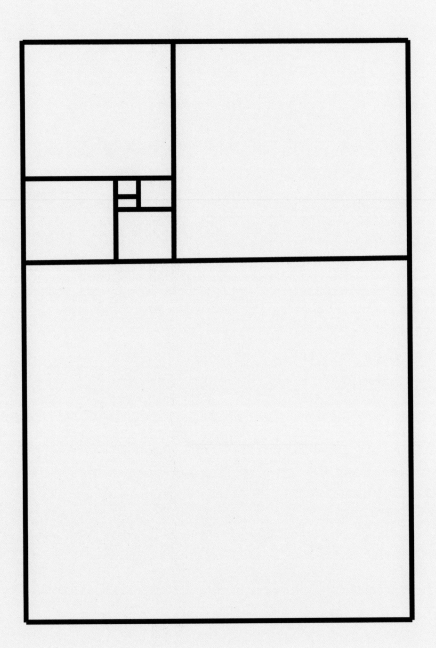

Over the next few pages, I will provide examples of three of my most commonly used compositions when I paint florals: spiral, triangular, and vertical. I'll also cover two important considerations to ensure that you plan your floral painting properly: positive and negative space, as well as the light source.

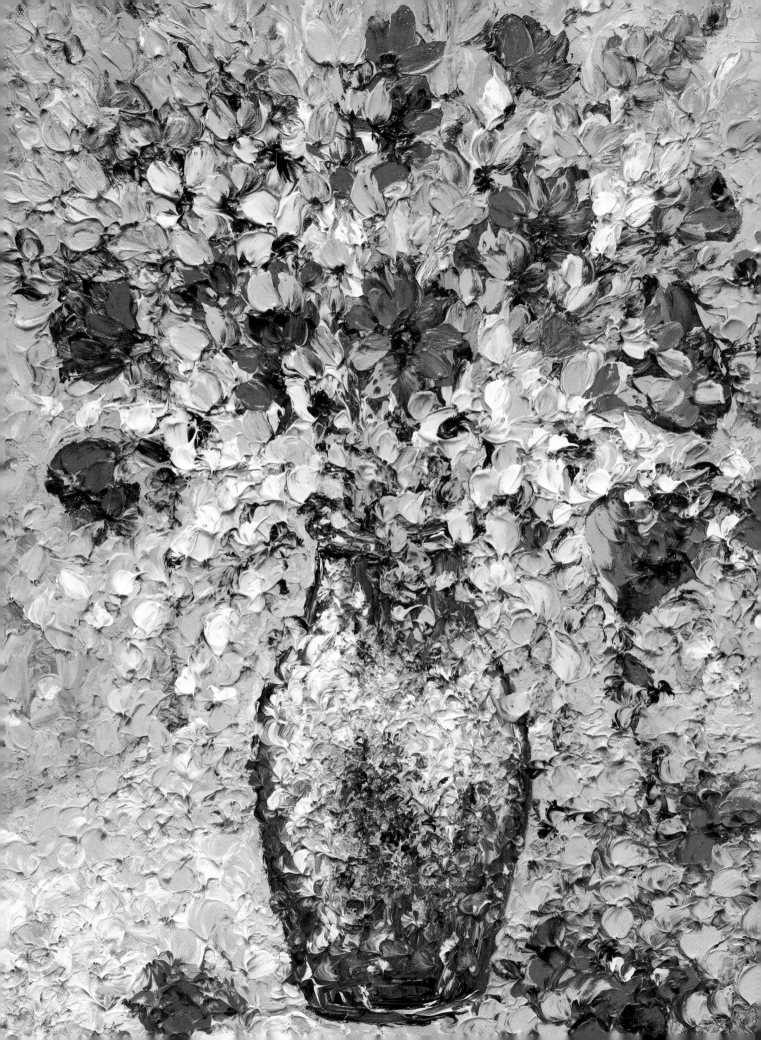

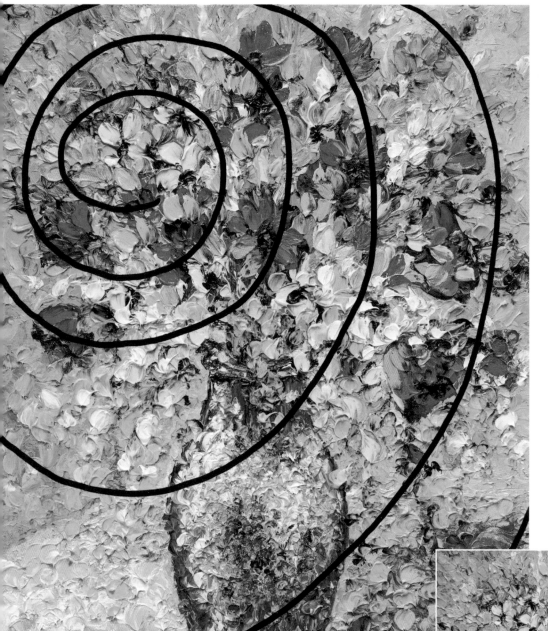

SPIRAL

One of my "go-to" compositions for representing a large bouquet of flowers featuring a variety of colors is the spiral composition, as shown in this floral bouquet. In this painting, the red flowers are placed in a spiral pattern, creating a nice flow in the placement of colors and giving the painting energy as the viewer's eyes follow the movement of color.

TRIANGULAR

In this next example, artist Lois Haskell masterfully placed sections of flowers in triangular shapes, giving the subject a nice balance, as well as an asymmetrical feeling to stir the viewer's curiosity. This type of composition helps create a guideline to ensure that there are no tangents and that the flowers don't look too symmetrical. Each time you pause to study a specific section of the floral bouquet, you may be delighted by the discovery of new triangular shapes.

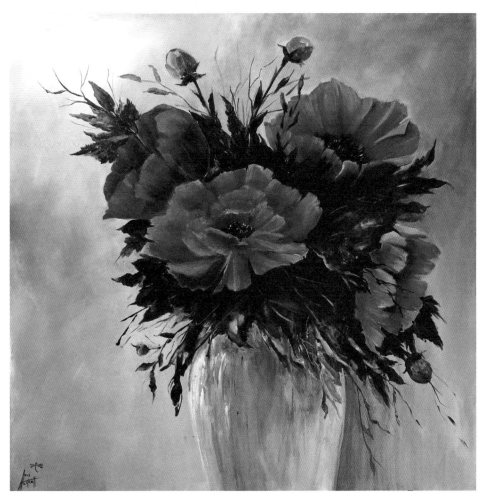

Artist: Lois Haskell

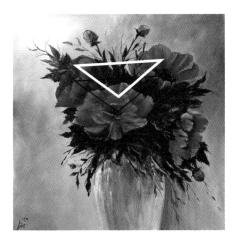 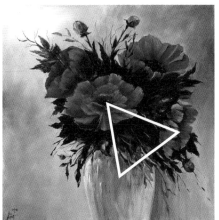 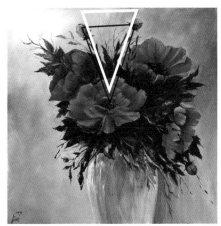

Over the top of each image, I've given you an example of a triangular shape tucked into this painting. How many more do you see?

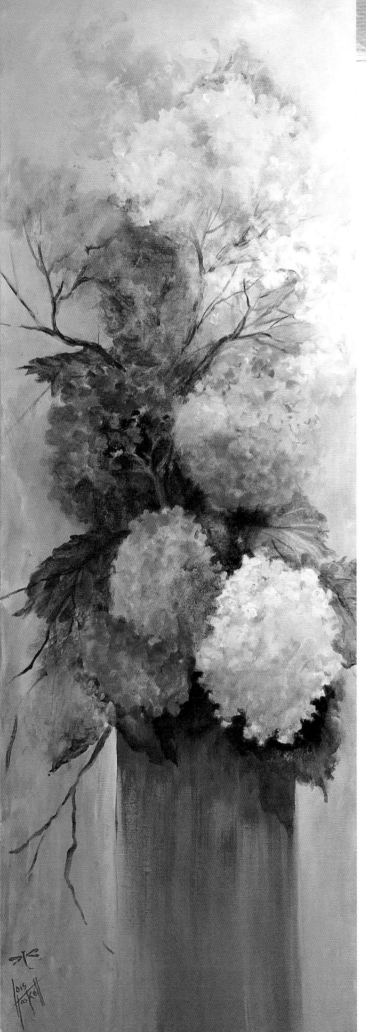

VERTICAL

Painting on a long, narrow canvas can feel modern and rebellious. I chose this vertical floral painting by Lois Haskell as an example of this rebellion. Hydrangeas are so round and unruly; placing them on a long, thin, vertical canvas brings a balance of opposites.

This painting is also a great example of a vertical composition. The flowers take up twice as much length as the vase, giving them two-thirds of the canvas. The vase and flowers appear to fade at the top and bottom, creating the illusion that the subject is larger than what is seen on the canvas.

Artist: Lois Haskell

POSITIVE & NEGATIVE SPACE

Floral paintings don't have to be designed around a bouquet. In this example, Lois Haskell created a contemporary-looking floral painting featuring a single flower.

The main goal with this type of painting is to ensure that no two areas are the same. If two areas look similar in shape and size, it creates a discomforting appearance and distracts from the intended composition.

Entry Point

Entry Point

Entry Point

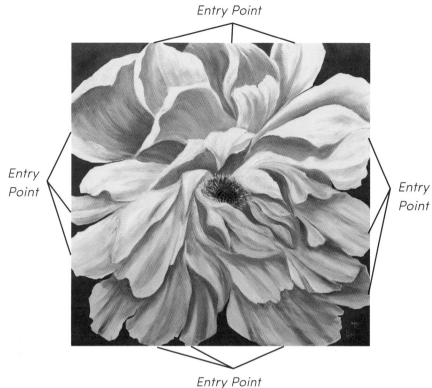

Entry Point

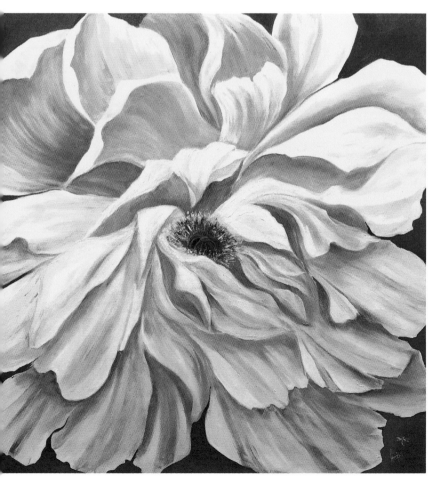

When painting large-scale flowers, it's important to feature several entry points. Notice how in this painting, the artist painted some of the petals to the edge of the canvas, creating the illusion that the flower is larger than the canvas. If the petals didn't touch the edges of the canvas, the flower would appear to be floating, and the painting would lack the energy of the viewer's eyes entering and exiting the canvas along the edges.

Also, note the artist's strategic use of colors. She chose two complementary colors: yellow and violet. Complementary colors are found on opposite sides of the color wheel; using this type of color scheme creates contrast and makes the image appear bolder and more dynamic.

Artist: Lois Haskell

Artist: Lois Haskell

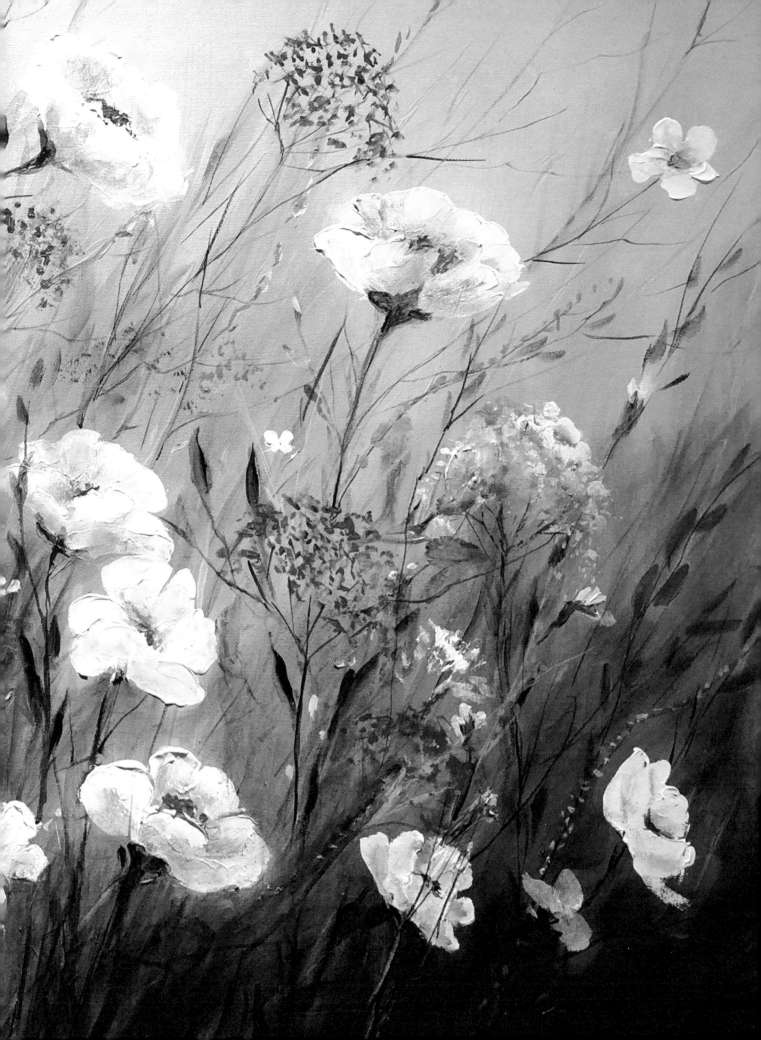

LIGHT SOURCE

The light source in a floral painting is crucial to creating a contrast in values as well as depth. Try to group the lightest values together or place a highlight on the flowers so that light appears to be shining on them. Also feature a gradation of values to the darkest areas, which are farthest from the light source.

Light Source

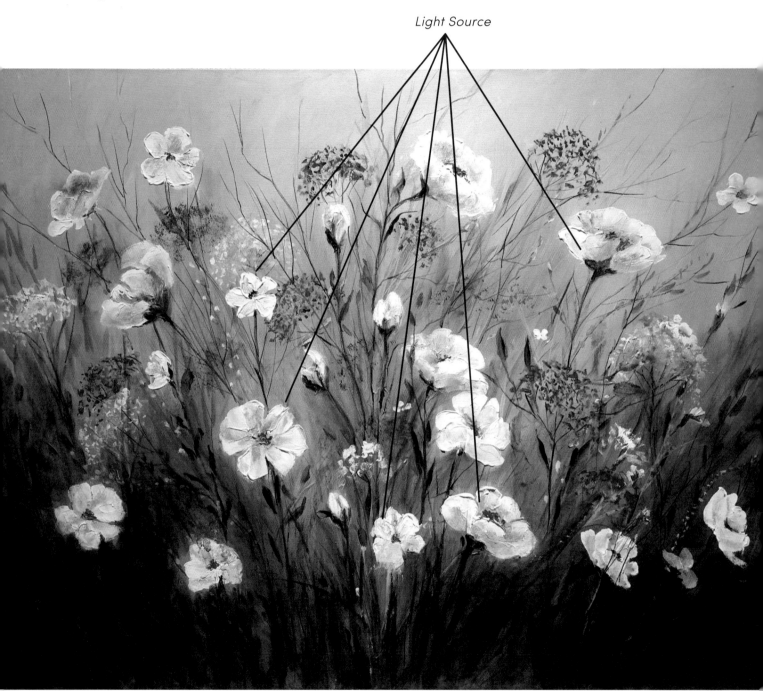

In the wildflower painting by Lois Haskell, she exaggerated the light source by giving the painting a silhouetted appearance. You can almost feel the warmth of the sun beaming off the white flowers, just as it would look if the sun peeked through the clouds and illuminated a field. To create this silhouette, the corners of the painting feature darker shades than the values in the middle of the painting. The white flowers that take center stage are brighter and pop with brilliance relative to the flowers that fade off to the sides of the painting.

Before starting your floral painting, remember to plan your composition and placement of colors so that they carry the viewer's eyes throughout the piece. Consider both positive and negative space as well as a consistent light source. These basic concepts will help you create your own floral masterpiece.

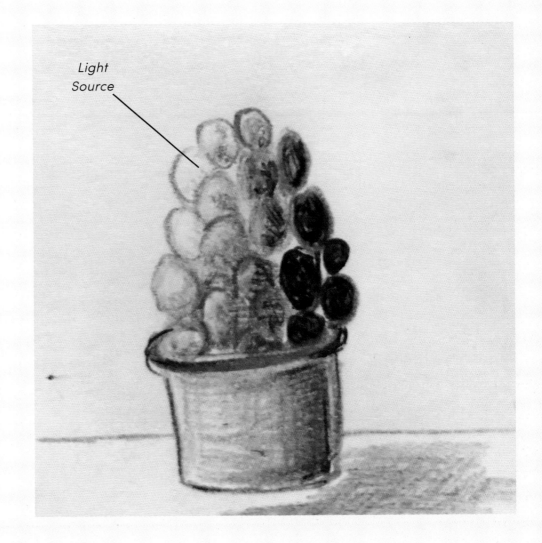

Light Source

TURNING PHOTOS INTO

Extraordinary
Paintings

Adding Color

Selecting the right colors to bring your photo to life and depict the appropriate mood requires creating color harmony and balance in your painting. This step-by-step project uses a reference photo of my father's stack of books. The books bring nostalgia and a sense of classicism and studiousness, so I had to be careful not to make this piece look too cartoonish through my use of color. To set the appropriate mood, I used a square tetradic color scheme of yellow, blue, red-orange, and violet. These colors give the painting balance, as they are equally spaced around the color wheel and include both warm and cool shades. The dark background and added highlights create a dramatic effect.

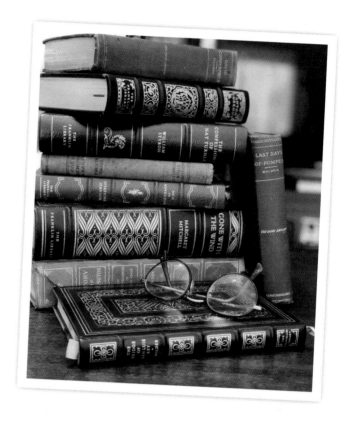

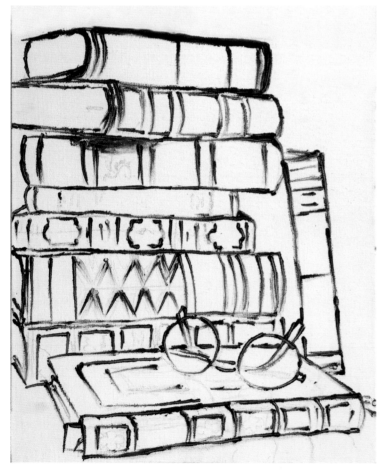

Plan the placement of your subject by sketching the basic shapes and details onto your canvas. Using an L-shaped composition as a guide ensures that the books sit off-center; avoid placing them in the middle of the canvas.

Then trace over the books with your darkest value to allow for contrast when the lighter colors are introduced.

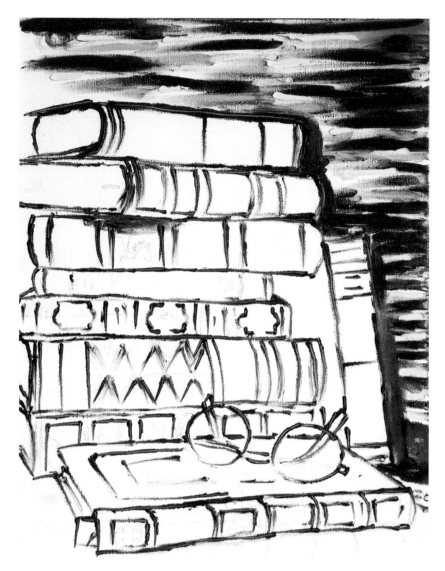

Add thick applications of color in horizontal lines to the background. It's important to use the same colors in the main stack of books; once blended, they will create unity between the background and the main subject.

tips

USE A SILICONE SQUEEGEE OR LARGE PALETTE KNIFE TO BLEND THE COLORS IN ALTERNATING HORIZONTAL AND VERTICAL STROKES AND CREATE A DARK GEOMETRIC BACKGROUND.

Once the background is blended, create a wooden table. A yellow hue gives the effect of a glare from the books onto the table.

Add shape to the books, keeping in mind the balance between warm and cool colors and the transition from cool to warm.

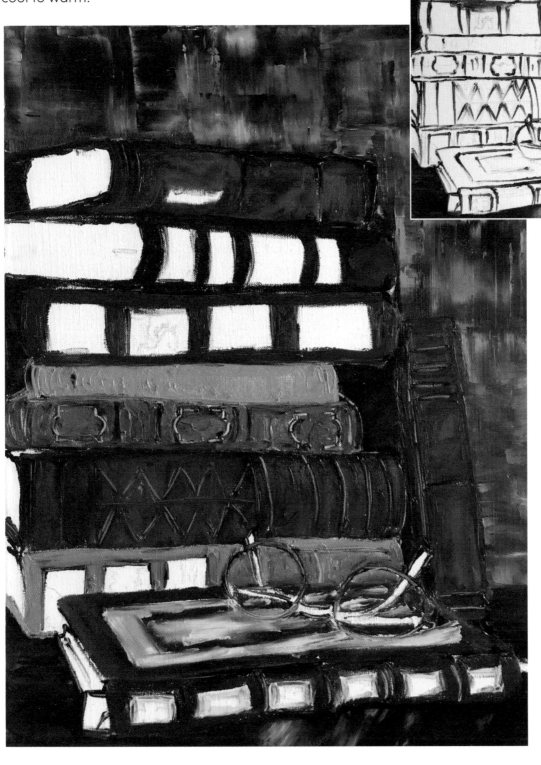

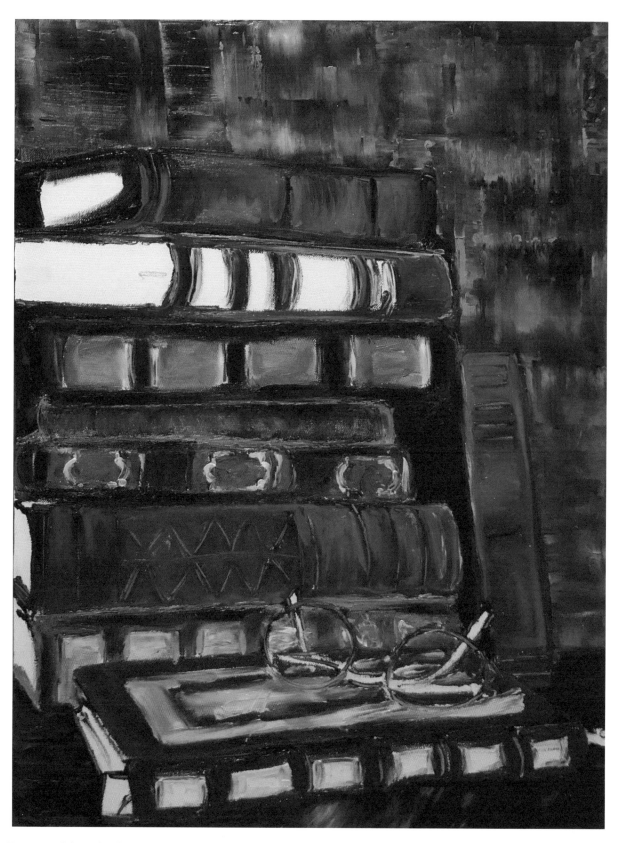

Begin adding highlights to the edges of the books using a rounded, vertical application. With horizontal books, this gives the effect of a rounded spine. Include highlights to represent shiny golden areas, and feature variety in your colors.

Prepare the pages of the books for more detail by applying a thin layer of brown paint. Keeping this layer thin prevents the colors from looking muddy and dull when applied over the brown paint.

Add detail and highlights to the pages. Avoid overblending; you want to create a nice contrast as well as a streaky appearance that looks like thin book pages.

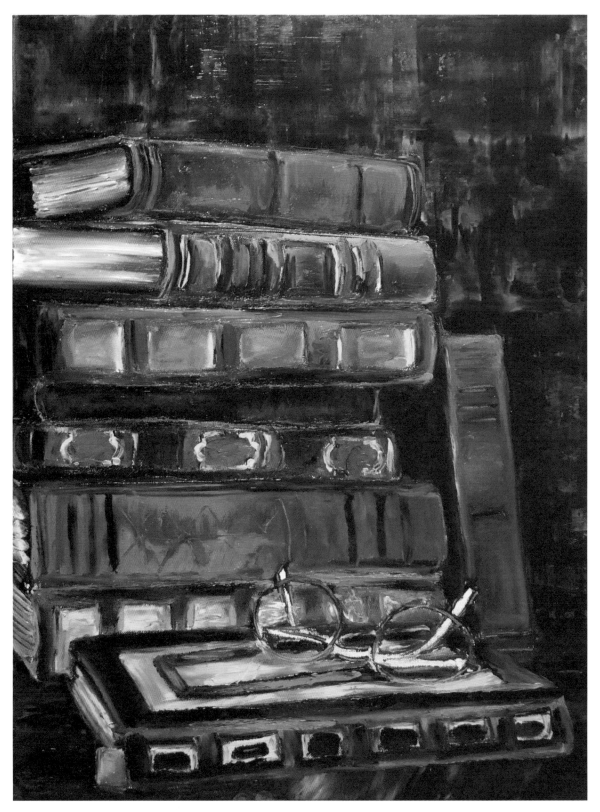

Start filling in details and highlights on the books with lighter and middle values. For a dramatic look, highlight the third book from the top and create the glow of a light reflection.

Finally, sharpen the highlights on the books' bindings, and add highlights to the glasses.

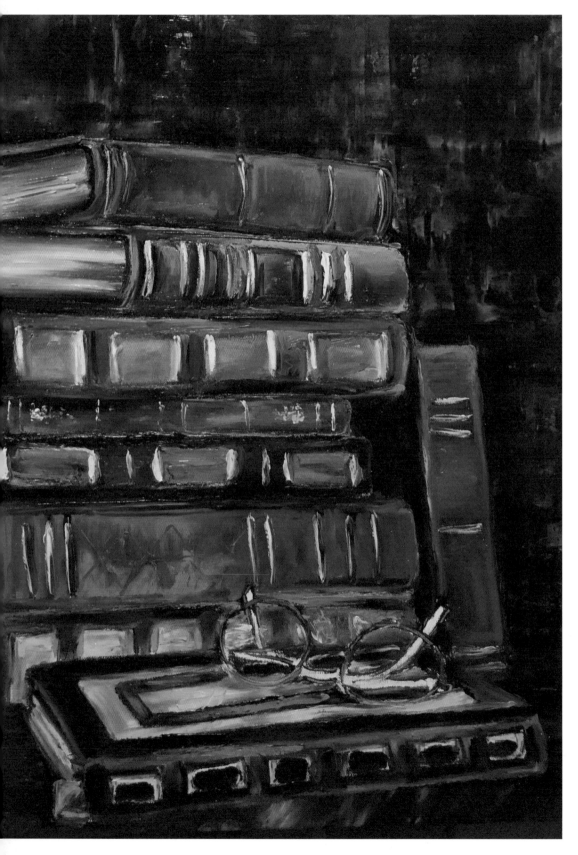

(Opposite) To recap, the painting started with a dark background. Middle to light values were then added to illuminate some areas, giving the illusion of light shining on the books. Using warm and cool colors adds harmony. The reference photo features more intense colors, but I chose to tone down the mood of the painting through strategic placement of colors that are in unity with the background. The result is a painting that reflects a nostalgic, classic feeling.

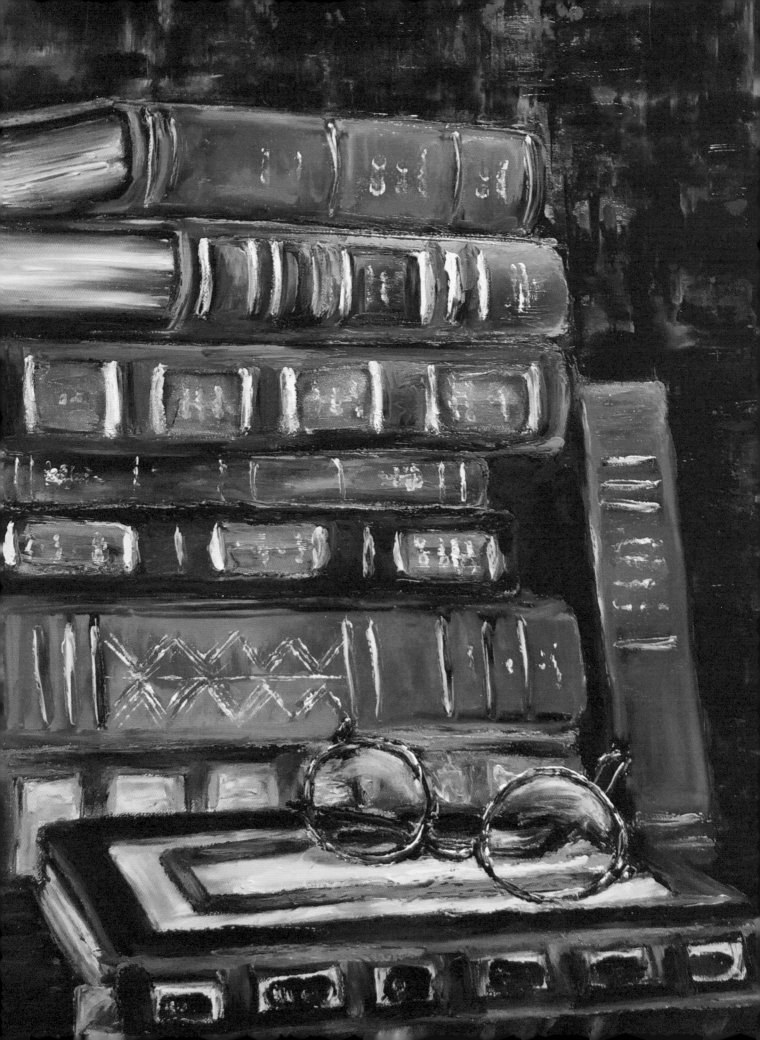

Creating Movement

While traveling recently, I was taken aback by the beauty of some daffodil fields blooming in the early spring. The sun was making its debut after a long winter, and a warm breeze blew across the field, causing the stems and flowers to bounce and wave in a rhythmic motion. The flowers almost seemed to be waving to passersby.

Creating movement in a painting can feel very liberating if you allow the paint applications to flow while keeping in mind that each stroke doesn't have to be controlled. The key to creating movement in a field of flowers is to apply a wave of motion between the colors. This same concept can also be used to depict a ripple or splash of water.

Here I chose a Z-shaped composition (page 57) to set up my angles, with a split-complementary color scheme of bright yellow, rich green, and red-violet for a dramatic contrast.

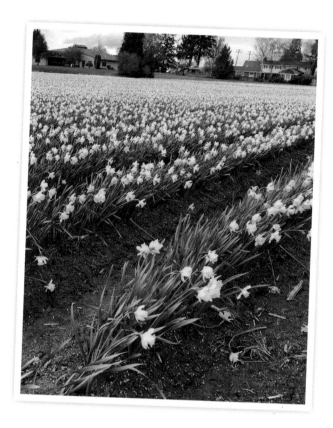

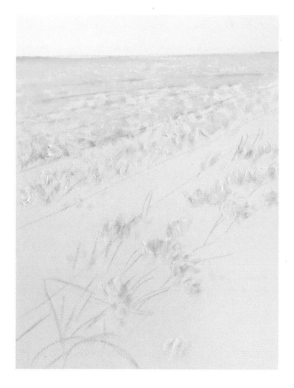

Start by sketching your subject onto the canvas. Mark the main angles of the field and the horizon line.

Then use yellow to depict the flowers. Start at the horizon line and work your way down the canvas, letting the paint applications become bigger and farther apart out as you near the bottom of the canvas. This creates the effect of flowers fading away at the horizon line and becoming larger and more defined in the foreground.

tip

WHEN PAINTING WITH A TRANSLUCENT COLOR LIKE LEMON YELLOW, IT'S BEST TO START WITH THAT COLOR TO PREVENT THE OTHER COLORS ON THE CANVAS FROM OVERWHELMING IT. THIS ALSO KEEPS THE AREAS WITH THE TRANSLUCENT COLOR BRIGHT AND BOLD.

Add the first three rows of stems using blue. The blue makes a subtle green when it comes in contact with the yellow and complements the colors that will be added later. Let the blue fade into the yellow, and add dots to the left side near the horizon line to imply that the row is disappearing into the distance.

Then fill the area above the horizon line to represent the sky. Next, apply mauve between the rows of flowers using long horizontal applications to create movement away from the rows of flowers.

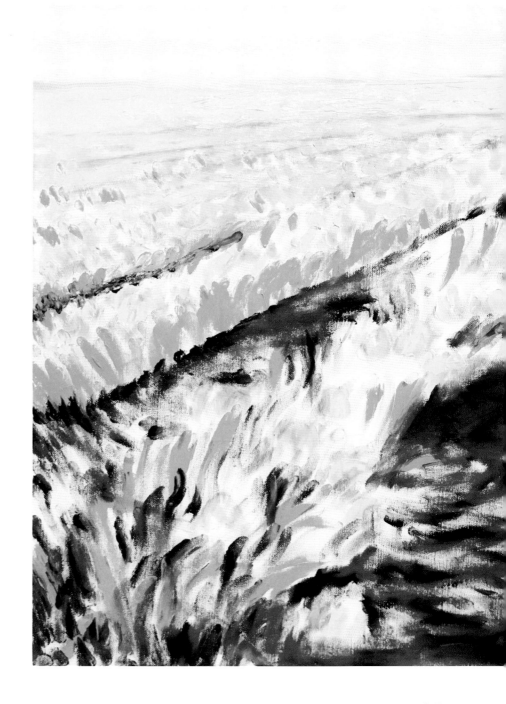

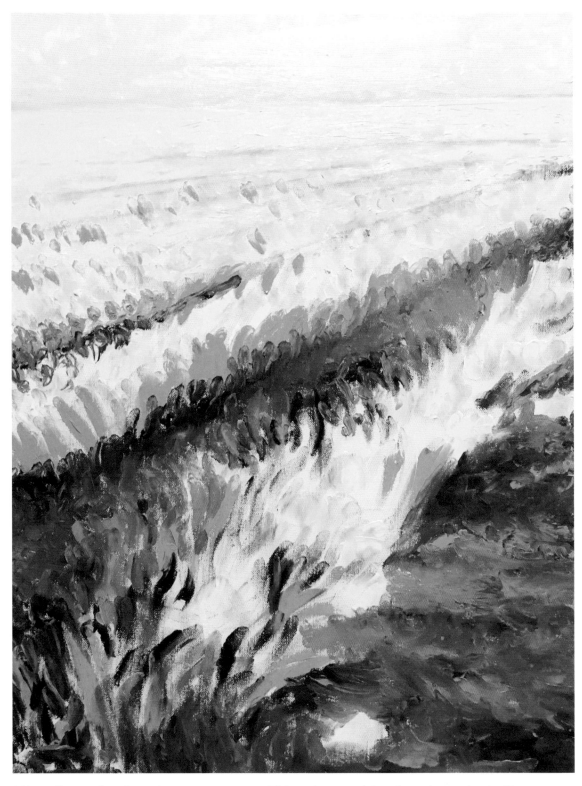

Mix yellow ochre into the mauve areas. This color combination almost looks like peanut butter and jelly mixed together and is one of my go-to combinations for pathways, as it creates a rich, earthy appearance. Use long horizontal strokes again, and avoid mixing and blending the paint, as you want the mauve to show through in some areas.

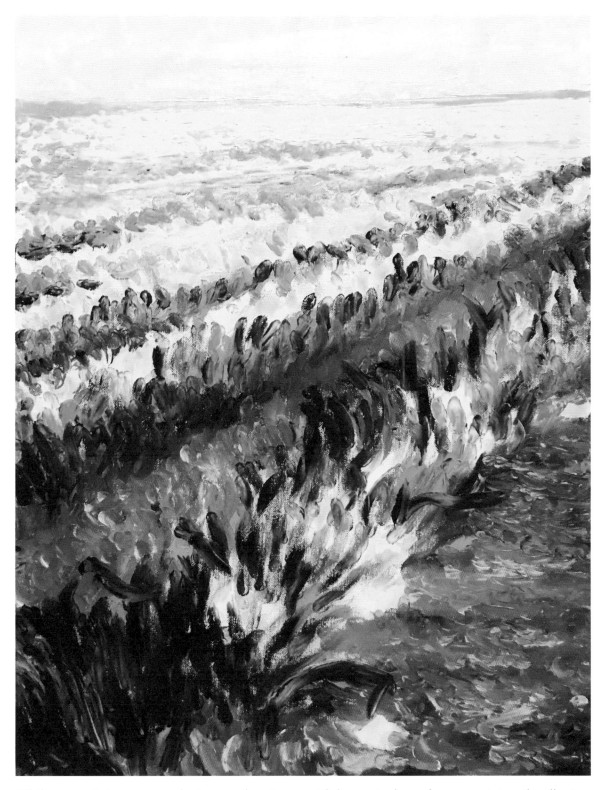

Fill the remaining spaces between the stems with long strokes of green, giving the illusion that the stems are bending.

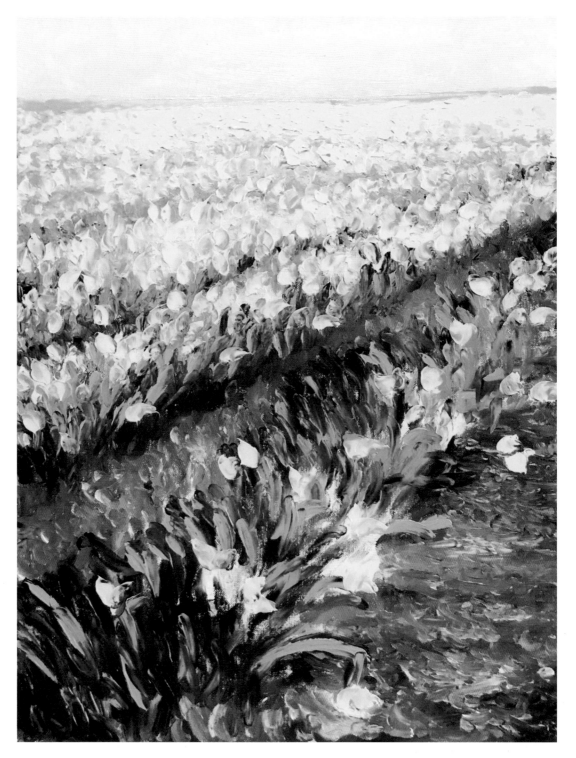

Add highlights to select stems at the bottom of the canvas. As you move upward, reduce the size of the strokes until they become small dots and create the illusion of a subtle hint of a row barely making an appearance at the top of the field.

Also add more yellow to any areas of the field that look too linear, and suggest light reflecting in the pathway with a light orange shade.

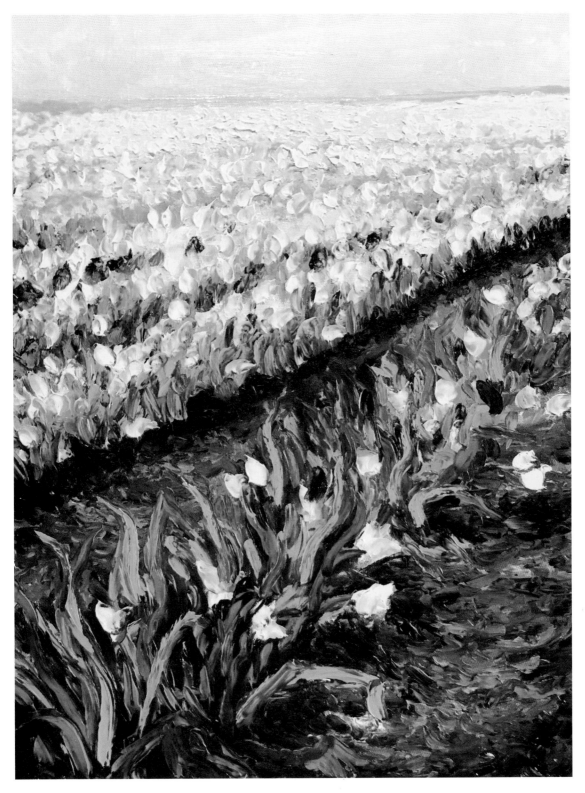

Now fill in any areas where the white canvas shows through. Then add more blue to the stems to help define their shape. Use fluid strokes to create wavy, exaggerated, and loose stems. This implies that they are blowing in the wind.

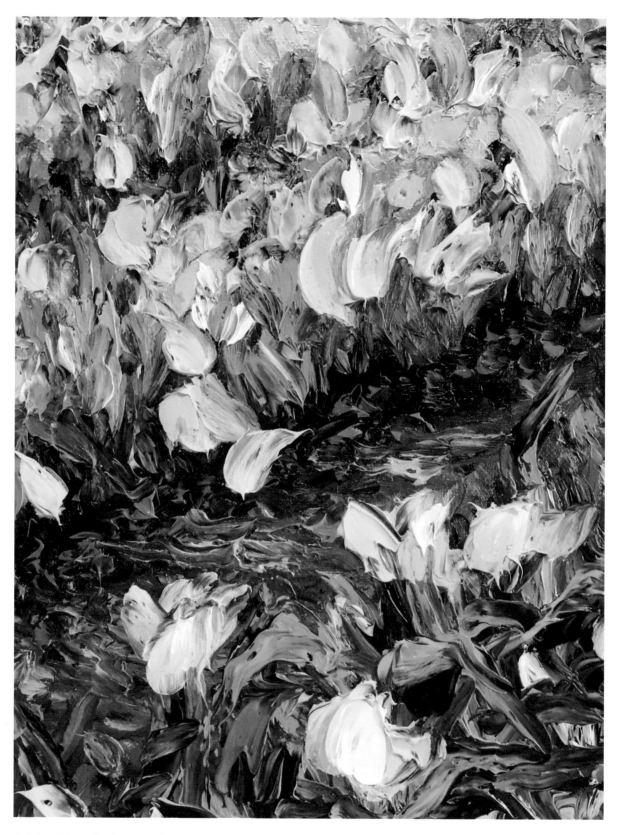

Add a hint of white to the sky and to the field as it cascades down to hit a few of the flowers in the foreground. With another shade of yellow, add richness and a subtle shadow on the petals of the flowers that you want to appear more defined.

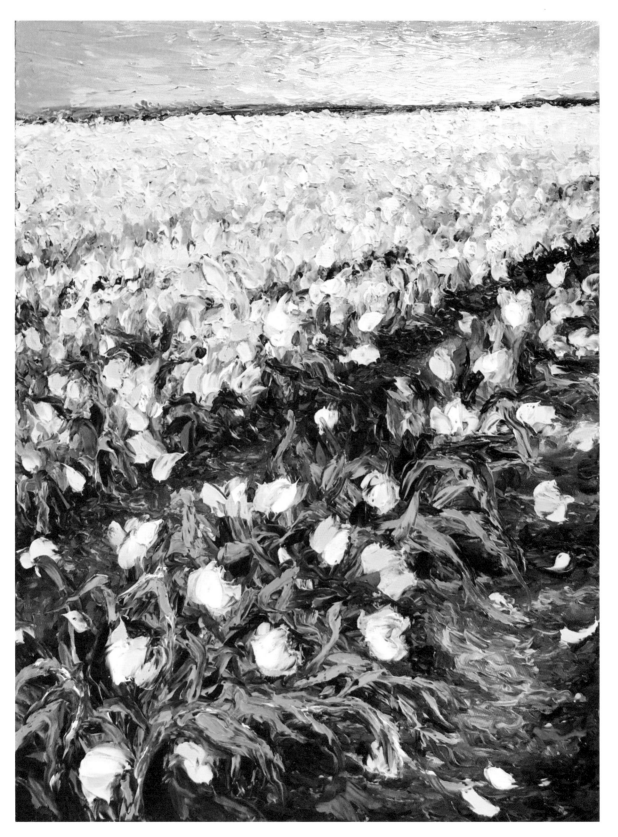

In the final step, revisit a few of the flower stems, dragging them out to exaggerate them a bit. This reinforces the wavy movement. The placement of the white draws the viewer's eyes from the top of the canvas toward the bottom.

Lights & Darks

Sunflowers make a delightful study when learning how to paint lights and darks and the values in between. Their blooms are yellow and violet, two complementary colors that naturally create a dramatic contrast. The petals reflect a variety of values, from light and medium to dark. The stems allow you to introduce another color, creating a triadic color scheme of yellow, violet, and green.

Begin by preparing the background. I like to place the paint directly onto the canvas and then use a shower squeegee to smooth the paint. This technique is a quick way to create an even coat.

(Opposite) Holding the squeegee and alternating between vertical and horizontal movements, create subtle, blended geometric shapes in the background. Then use the tip of a palette knife to scrape the outline of the subject. I used an L-shaped composition (page 54). Fill in the center area of the sunflowers with your darkest value as you begin to build contrast in the painting.

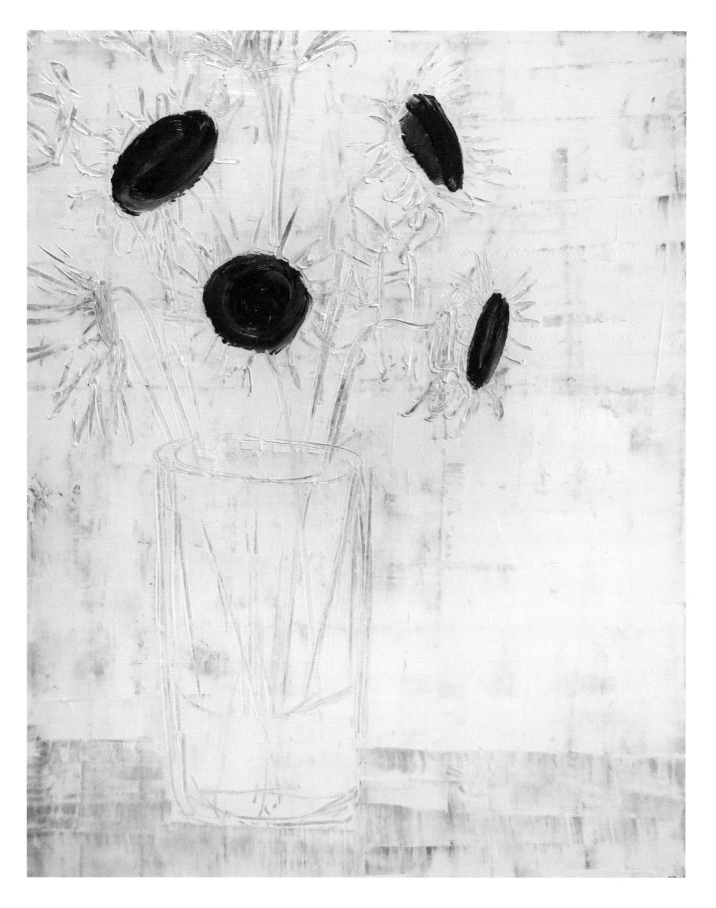

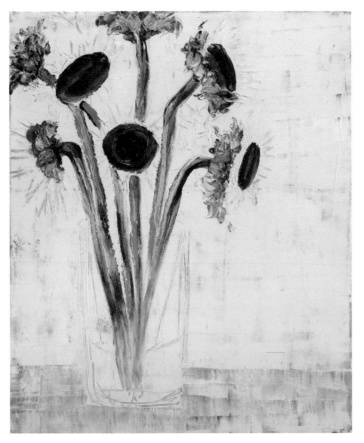

Create the sunflower stems. Notice that the area where the sunflower meets the stem is almost as thick as the length of the petals. Paint an odd number of stems; you can always add more later if necessary.

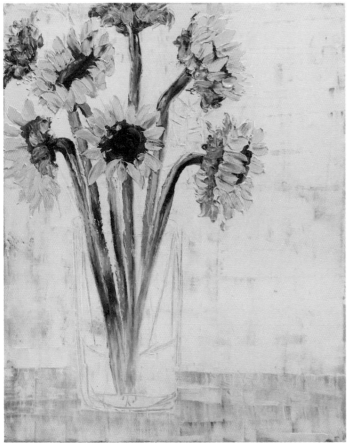

Add yellow using crescentlike strokes, starting at the base and ending in an outward-facing point. Try to capture some of the center color so that it mixes with the yellow, creating a shadow effect between the petals. This will take practice. If you try to control the strokes too much, they will look forced and unnatural.

Then layer a lighter shade of yellow on a few petals to show where the light source would hit the flower.

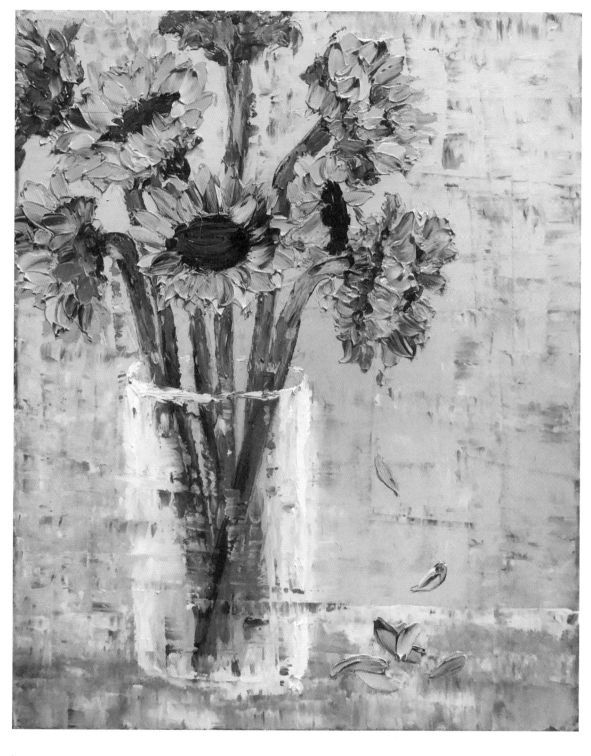

Begin adding highlights to the stems and vase. Outline the vase as well.

ADDING A FEW LOOSE PETALS TO THE BOTTOM-RIGHT SIDE OF THE CANVAS CREATES MOVEMENT AND CARRIES THE EYE FROM THE BOLD YELLOW SURROUNDING THE SUNFLOWERS TO OTHER AREAS OF THE PAINTING.

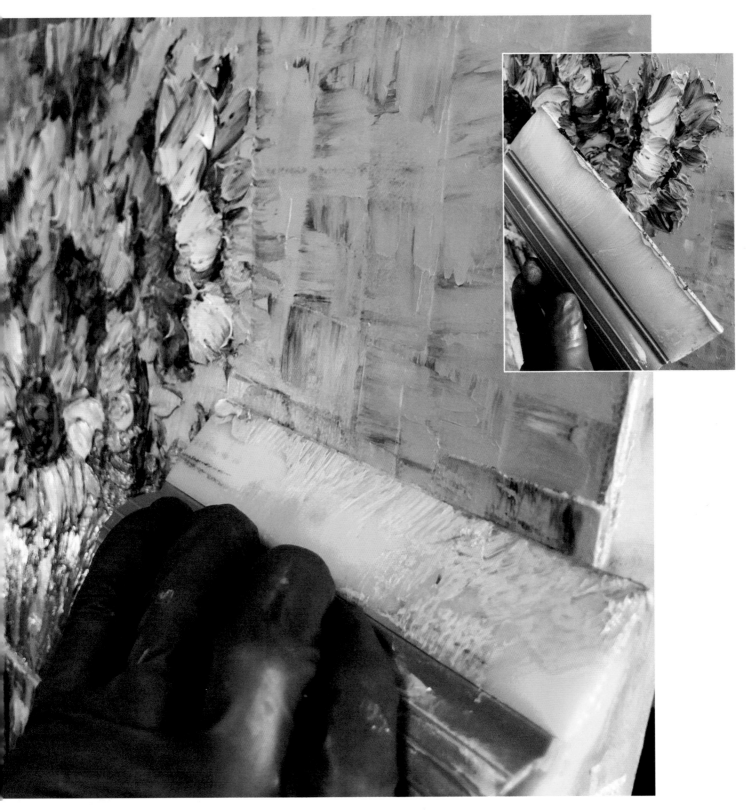

Use a squeegee to blend areas of the painting, add interest and depth to the background, and create a contemporary-looking painting. Alternate between horizontal and vertical strokes, and take care not to touch the freshly painted flowers.

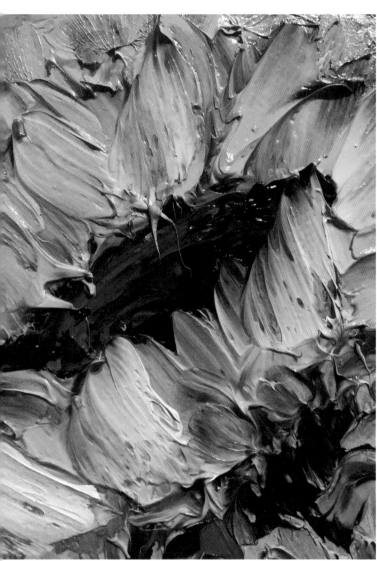

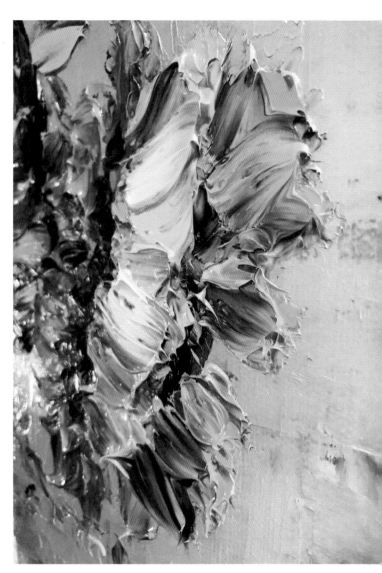

Add final touches of highlights and exaggerate the light source by adding yellow and a subtle touch of white to select petals. This adds a nice contrast to the darkest values and also balances out the vase in the white and bottom area of the painting.

Use the last application of paint to build up texture on the flowers by allowing the paint to sit on top of the previously applied paint. This last layer should appear thick and sculpted.

Use a grid (pages 10–11) to check if your subjects fall into their correct focal points. I noticed that two of the flowers at the top were distracting because they looked too heavy and out of harmony with the rest of the yellow flowers, so I adjusted their shape with light blue, creating more space and an airy feeling between the flowers and the edge of the canvas.

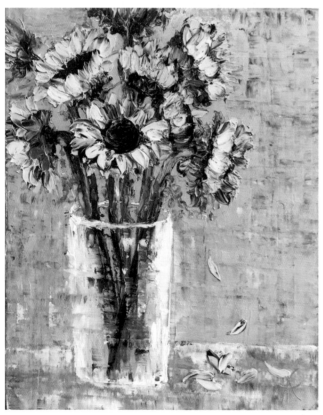

I CHOSE THIS SUBJECT TO STUDY THE CONTRAST BETWEEN LIGHTS AND DARKS IN A PAINTING. LOOKING AT MY FINISHED WORK THROUGH A BLACK-AND-WHITE FILTER HELPS ME DETERMINE IF THE LIGHT AND DARK VALUES ARE PRESENT AND BALANCED.

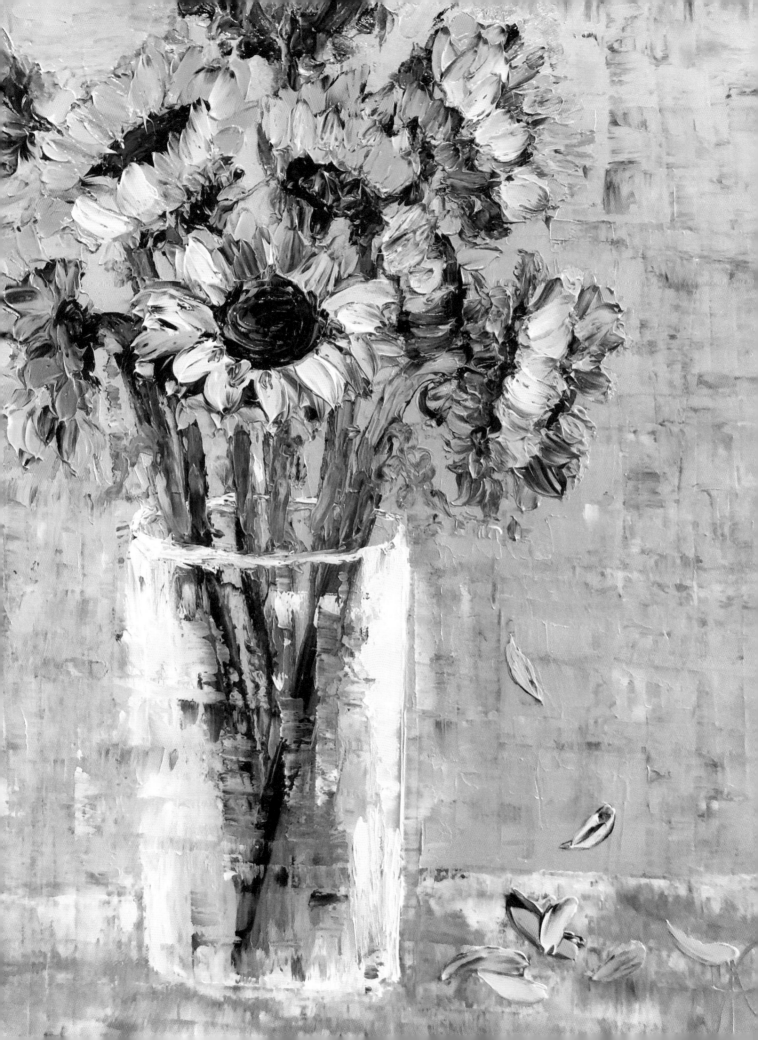

Perfecting the Background

My reference photo for this painting features a lot of elements, but I chose to eliminate the ones that didn't enhance the subject, instead focusing on the peacock. Removing unnecessary elements gives me the opportunity to be more creative with the background.

At first glance, this painting may look complex. Breaking it down into sections, however, makes it more approachable.

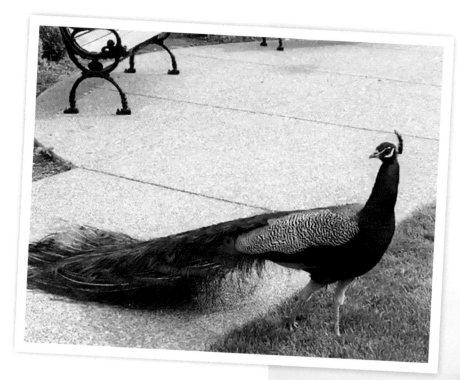

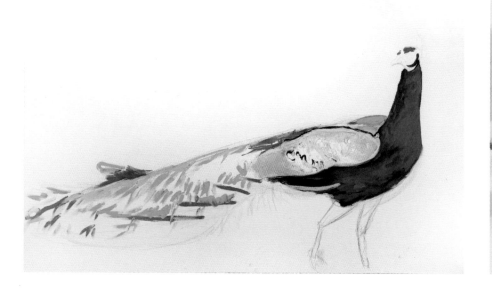

Sketch the outline of the peacock onto a long horizontal canvas. Follow the rule of thirds (page 10) to block in the basic shape of the bird and consider where to place the background.

Then begin to outline the body of the peacock with paint. Create a shadow on the underside of the body and shape the wing, leaving some areas of the canvas white.

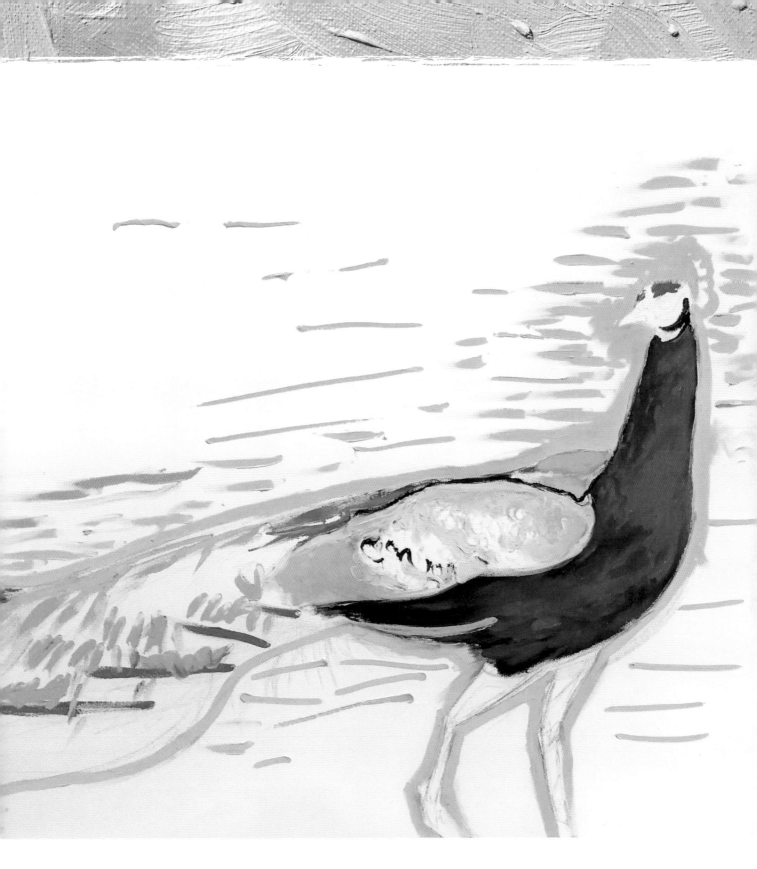

Begin creating the background by applying an outline to the peacock, as well as heavy amounts of paint in long horizontal lines around the bird's head and body. Leave no white canvas showing along the outline of the peacock to avoid cumbersome touch-ups later.

Continue to fill the background with colors until you meet the edge of the canvas.

tips

PRACTICE CREATING THE BACKGROUND ON A SMALLER CANVAS OR PANEL UNTIL YOU ARE HAPPY WITH YOUR RESULT. USE MORE OR LESS OF A CERTAIN COLOR TO ACHIEVE DIFFERENT RESULTS.

To finish the background, blend the colors using a squeegee. Alternate between horizontal and vertical strokes until the entire background is covered in geometric shapes.

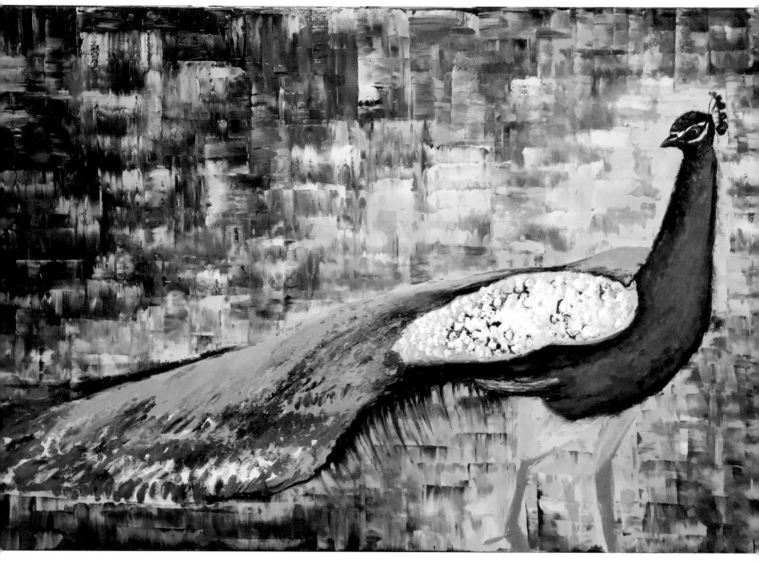

Now add details to the bird. Use a random swirling pattern inside the wing, and add a shadow underneath it. To the left of the wing, create dark feathers that transcend into the long, colorful feathers that make up a peacock's tail. Using white, outline the eye and add a tiny dot for a reflection.

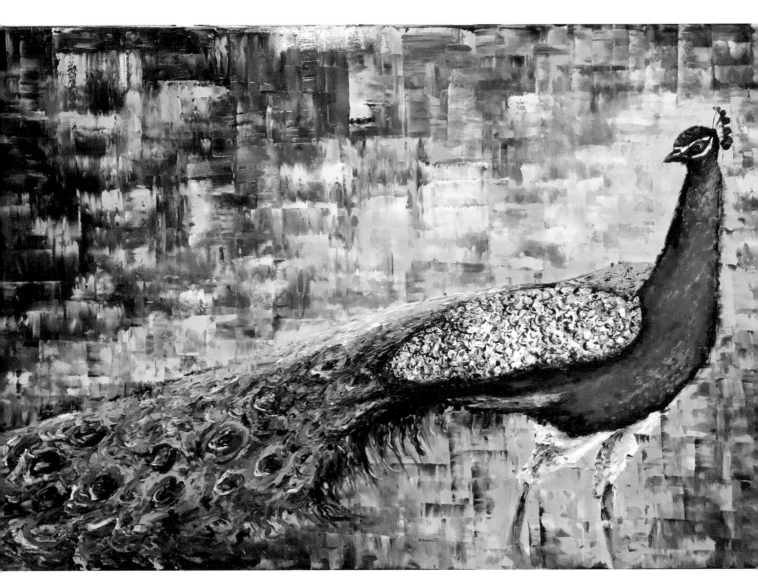

Add details to the tail by creating circles to make up the "eyes" of the feathers. Finish the details in the wing by outlining the spots or swirls, and add highlights to the wing.

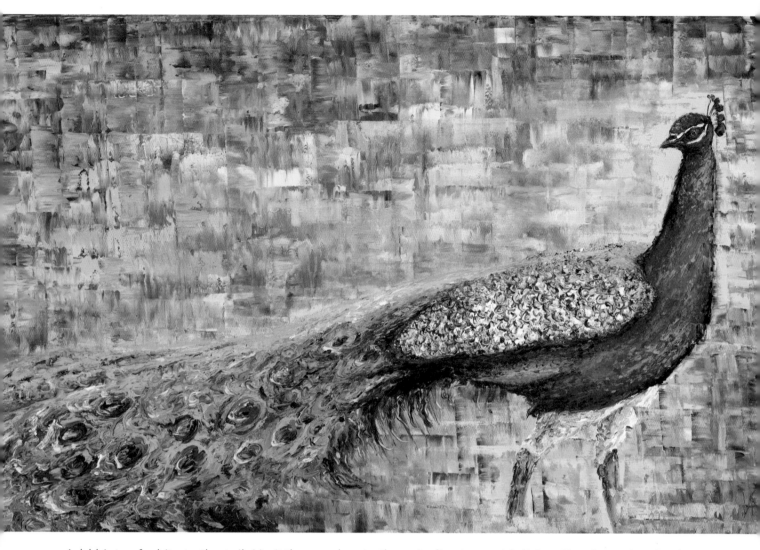

Add hints of white to the tail. Limit the number to three to five to avoid distracting from the shades of blue and green that make peacock feathers unique. With a dry squeegee, blend the feet, tail, and body into the background to connect the main subject (the bird) into the contemporary-looking background.

Closing Thoughts

Composition is not something that can be perfected overnight. As with most concepts, the more you practice it, the more confident you will become in building a strong composition. Eventually your skills at building a successful composition will become habitual, and knowing how to start will require less effort.

The concept of composition is a broad subject, and this book is designed to give you a basic understanding of the concept as well as the application of a few basic principles. When creating this book, I sat down with a few established artists to compare their understanding and education of the subject with the knowledge I've obtained over the years through my own practice and study. I chose to feature some of their art throughout this book to provide broader examples for this important subject.

If you are interested in viewing more art from any of these artists, their work can be seen online:

Amanda Schuster:
https://www.whitedogwatercolors.com/

Lois Haskell:
https://loishaskell.com/

Irena Jablonski:
https://fineartamerica.com/profiles/irena-jablonski.html

Ré St. Peter:
https://www.paintedhillstudio.com/

About the Artist

Artist: Inese Westcott

Walking into a room and seeing a Kimberly Adams painting on the wall is bound to stop you in your tracks. It's not just that the colors ignite the space or that the images dance with light and energy; it's that they transport you to another world. Nearly every one of Kimberly's impressionistic canvases offers you a pathway to a better place where joy, happiness, and positive energy await.

Following in the footsteps of the Impressionists, Kimberly applies dozens of daubs of paint to every canvas, allowing the pure, vibrant pigments to visually blend on the surface and in the viewer's eye. She adds her own modern twist to the process by painting only with her fingertips. In her words: "Finger painting feels natural. I'm not obstructed by tools. When I use only my fingers, I feel I have more control on how to apply and move the paint." And move it she does! To watch Kimberly paint is to understand where the joy and energy come from. Her hands literally dance across the canvas, sometimes blending the colors to create dimension and depth and sometimes allowing the paint to remain untouched, adding rich texture to the image's surface.

Like so many artists, Kimberly loved art from a young age but initially chose a "safer" professional path—in her case, a successful career in retail that spanned more than 20 years. But eventually the lure of painting proved irresistible. Kimberly embarked on a journey of discovery, studying the work of Impressionists from the past and present and mastering her own techniques in her studio.

When it came time to launch her professional art career, she relied on her self-confidence and business acumen to chart her own course, and the results have been remarkable. In just a few short years, through brick-and-mortar shops and online galleries, her work has been collected into several private collections. Kimberly also thrives on encouraging other aspiring artists to pursue their dreams, which is why she enjoys serving as a board member for Kirkland's Parklane Gallery, as well as the chair of the Kirkland Art Walk.

Kimberly is currently represented by Cole Gallery in Edmonds, Washington; The Grand Fine Art Gallery in Jackson Hole, Wyoming; and Parklane Gallery in Kirkland, Washington. Canvas reproductions of her works are also available on iCanvas.com. For more information about the artist, her classes, and available works, please visit www.artbykimberlyadams.com.